IMAGES
of America

YUCAIPA
1940s–1980s

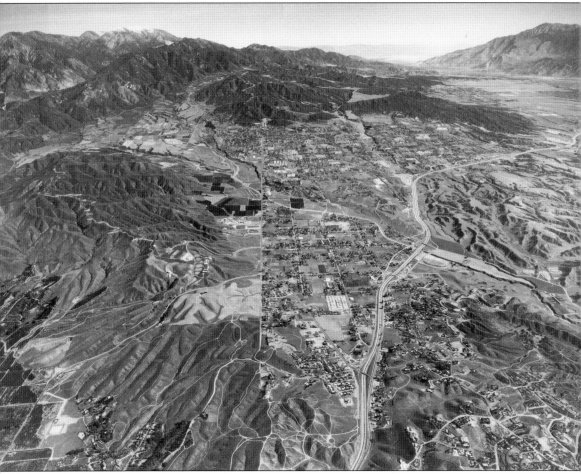

This aerial view of beautiful Yucaipa was taken from an altitude of 10,000 feet in September 1953 by Aerial Surveys from San Bernardino. It shows Dunlap Acres at mid-center, Calimesa in the upper right below Black Mountain. Oak Glen at upper left, and Yucaipa is in the middle. In the background are the San Bernardino Mountains. Mount San Jacinto is at far right of center background. Mount San Gorgonio, which is the highest peak in Southern California, is near the right of the snow-capped peaks. Mount San Bernardino is at the far left. The community at the time was very agricultural, but the post–World War II boom was bringing housing tracts and new neighbors.

ON THE COVER: Owner Earl Price's Yucaipa Theatre opened in January 1947 to the jubilation of the town's young people. H. W. "Red" Miller managed the 350-seat, $40,000 modern theatre, a cement-block structure with a pale green interior and air-foam cushioned seats. Movies were shown every day of the week, with additional matinees on Saturdays and Sundays. (Photograph courtesy of the Yucaipa Valley Historical Society.)

IMAGES
of America

YUCAIPA
1940s–1980s

Yucaipa Valley Historical Society

ARCADIA
PUBLISHING

Published by Arcadia Publishing
Charleston SC, Chicago IL, Portsmouth NH, San Francisco CA

Printed in the United States of America

Library of Congress Control Number: 2009924704

For all general information contact Arcadia Publishing at:
Telephone 843-853-2070
Fax 843-853-0044
E-mail sales@arcadiapublishing.com
For customer service and orders:
Toll-Free 1-888-313-2665

Visit us on the Internet at www.arcadiapublishing.com

This book is dedicated to Yucaipa's first families. They saw the potential of this land as a great place to live and began and developed the community, in the process creating the traditions so beloved by its residents today. We include in our dedication our eternal gratitude to the men and women who protected our country and Yucaipa in World War II and in the conflicts since. We add each and every resident who has shared the community ideals that have strengthened Yucaipa and made it a real hometown.

CONTENTS

ACKNOWLEDGMENTS

As the volunteers at the Yucaipa Valley Historical Society put together the first Arcadia book, *Yucaipa*, a strong desire to continue sharing our history in a pictorial form developed. When the call from San Francisco came saying we should do a second edition, there was much jubilation among the tribe.

Claire Marie Teeters and Harry Birkbeck developed a plan as Char Lenz, Marlene Humphreys, Kandie Cansler, and Ann Whitlock started sorting photographs. Humphreys put them in chronological order and Teeters began the layout, placing photographs into numbered positions.

Jack Curtright designated and built the computer system. Teeters fired up her unit and started writing the book. Of course, she saved it on her desktop, which had Curtright rolling his eyes, but, being good-natured, he set up a back-up system and began the scanning. Hank Cobb assisted.

Bob Rippy and others went to work sorting photographs, too. Marj Ford and Helen Ruggles spread the word on needed items.

At the same time, Wilma Hanson, Steve Maurer, Beverley Coffin, Ellen Benefiel, Mhila Curtright, Tom Ziech, Beverly Patrick, and Jan Lemon began the research by reading all editions of the Yucaipa *News Mirror* looking for significant events.

Birkbeck began delving into the society's files, checking data with the help of archivist Barbara Dowell. Calls went out for specific photographs and many people, including Jackie Deaton, Carolyn Traylor, Cansler and Hank Wochholz shared their personal images.

All photographs used in this book come from the Yucaipa Valley Historical Society unless otherwise noted.

Two and a half months later, Teeters shut the door on the workroom and started the serious writing. Scanner jockeys Curtright and Ken Dowell took their places. Proofreaders David Miller, Rippy, Lenz, Ford, Ziech, Benefiel, and Birkbeck started their work, and before long, the book was developing. Yucaipa's history merged with the photographs. About then everyone remembered photographs that would be ideal, and pictures moved around or were replaced. Captions were rewritten. Great discussions were held on what to keep in and what to leave out of the book. Arcadia editor Debbie Seracini and Teeters happily e-mailed back and forth through the process.

There was frenetic activity as the team worked, but as the last week of effort started, there was happy chatter of what kind of celebration to hold.

And we did celebrate. Oh, yes, there was joy in Yucaipaville.

INTRODUCTION

The 1940s were exciting years in Yucaipa. After surviving the lean times of the Depression and sticking together through World War II, Yucaipa developed a central business district, even as it continued its agricultural-based economy. Longtime residents and fresh arrivals started new homes, schools, and churches, and these were soon thriving. Students still rode their horses to school, but more vehicles rattled along the streets. Yucaipa got its first fire station, constable, bank, and theater.

Community events, including parades and fairs—which changed from Apple Shows to Peach Festivals—continued with enthusiasm. Agriculture flourished, along with chicken, egg, and rabbit production.

Families flourished as well, and churches and local benevolent organizations formed to provide services and amenities for all Yucaipans, including the town's first teen center.

The 1950s brought a hospital, improved fire service, and more businesses. The Yucaipa Woman's Club worked to save the oldest building in town—the Yucaipa Adobe—and the Yucaipa Chamber of Commerce lobbied the County of San Bernardino for local services, including road improvements and park development. New grocery stores and businesses sprang up. The strong economy and the huge swaths of available land in the area brought a building boom. Orchards and farms gave way to new housing subdivisions and mobile home parks. The town's first sheriff's deputies worked from a telephone in the fire station and in 1957, the first sheriff's station opened on Yucaipa Boulevard. School populations increased and a junior high was constructed.

The 1960s were also boom years. Agricultural production continued to decline as more ranches were converted into housing tracts and new businesses. Clubs and other civic organizations established popular hometown parades, festivals, and fairs. With the increased population, water usage was becoming an issue. More schools were built, including Yucaipa High School. Yucaipans played together, argued together, and worked out their differences at community meetings or in the ballot box. Road improvements and municipal service needs were important issues. Yucaipa's residents again discussed incorporation, but again the idea failed to carry the day.

Agricultural businesses were increasingly forced into the fringes of the community in the 1970s, as developers built houses in traditional farming regions and sold them to homeowners who protested the neighboring farms' flies and odors. Debates over water, water quality, and a moratorium on development kept the local courts busy. Crafton Hills College opened, providing Yucaipans with higher education opportunities right at home. Grocery stores became supermarkets. Shopping centers clustered smaller businesses together with larger anchor stores. Independence Day celebrations centered at Seventh Street Park.

As the 1980s approached, residents had learned to speak for themselves with the County of San Bernardino. Third District supervisor David McKenna appointed nine Yucaipa residents to the Yucaipa Municipal Advisory Council, which did hear issues, make recommendations, and gave the county a focused voice. Sports activities were a major activity for everyone. The Yucaipa Regional

Park opened, a new bridge at the 1-10 intersection at Yucaipa Boulevard was constructed, and business continued. After 15 years of delays due to controversy and lawsuits, the Yucaipa Valley Water District opened the sewer plant, providing the opportunity for major construction.

What would become Chapman Heights was a much debated project. The need for major flood control improvements were considered and woven into the development. The alternative was piece-meal portions of land developing with out a cohesive plan for infrastructure and services.

Frustrated with the county over the need for street improvements and desiring increased municipal services, the community placed incorporation on the ballot, but it failed. Many feared the loss of the rural ambience and a change to the hometown atmosphere.

However, another effort in 1989 was successful and in November of that year, Yucaipa became the 22nd city in the County of San Bernardino. It was official—Yucaipans were not just part of a great hometown, they became responsible for themselves as residents of the City of Yucaipa.

One

THE 1940s

SURVIVING AND THRIVING

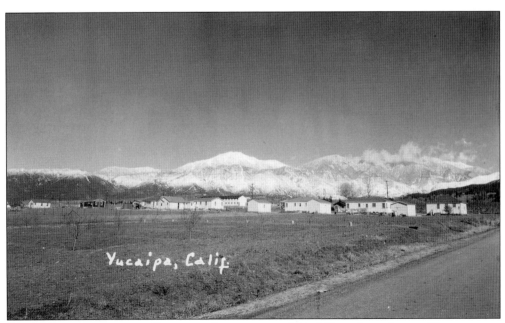

This 1947 view shows upper Yucaipa with snow-covered foothills and new homes. The two-story structure no longer exists.

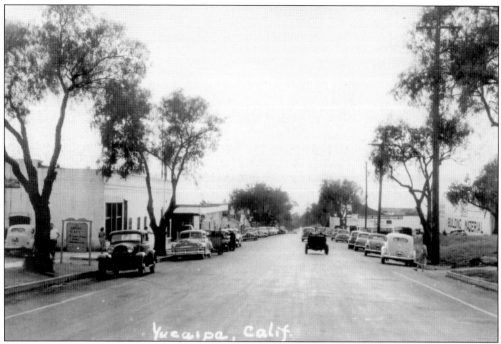

By the 1940s, the pepper trees along Yucaipa Boulevard were well established, and the uptown area along California Street was a busy business district. The Corner Market and the post office stand on the left, across the street from Holsinger's Lumber and Hardware. (Photograph courtesy of Toni Muirhead.)

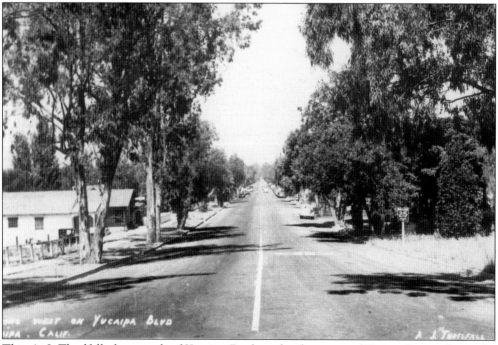

This A. J. Threlfall photograph of Yucaipa Boulevard, taken west of Bryant Street, shows the pepper and eucalyptus trees in full glory.

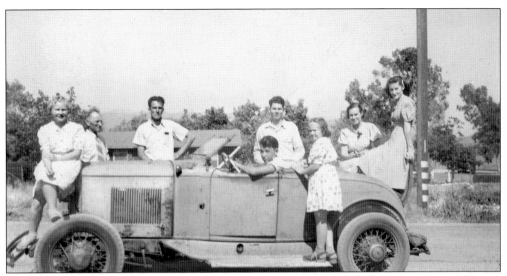

Cy Barnett sits behind the wheel of his 16th birthday gift, which cost $15. From left to right are sister Helen Barnett, father Garrold Olda "G. O." Barnett, brother Howard Barnett, Ken Cathcart, sister Barbara Barnett, sister-in-law Marie White Barnett and Margie Cathcart. This *c.* 1940 photograph was taken at the corner of Second Street and Yucaipa Boulevard.

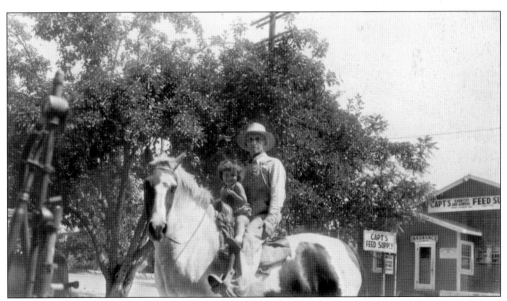

While automobiles were certainly the most popular mode of transportation in the 1940s, horses could still be seen downtown. In this photograph, judge G. O. Barnett has his granddaughter, Kandie Barnett, on his steed. Notice Capt's Rabbitry and Feed Supply store at 113 Second Street in the background. Rabbitries and egg ranches were becoming major businesses in the community.

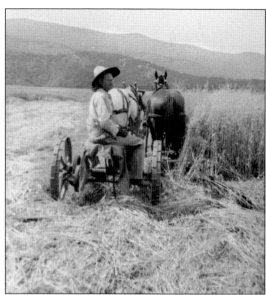

Vet Overly harvests oats on the Casa Blanca Ranch where he was foreman. The Overly family lived on the ranch for many years. They moved to the nearby 1886 Pass Schoolhouse building after the school closed in 1985.

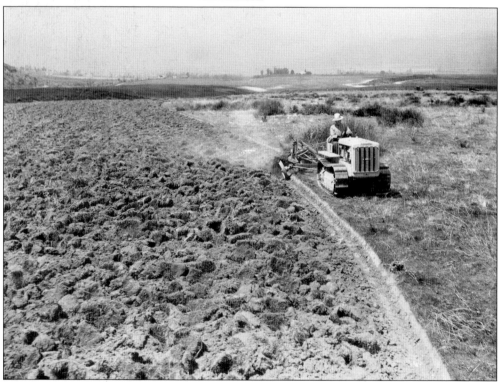

Vet Overly is plowing the Casa Blanca fields around 1944. In the early 1940s, large plots of land were turning over to new owners. Leon Atwood, who owned the Casa Blanca ranch, bought Bill Clyde's ranch and expanded his holdings to over 1,100 acres, becoming the largest individual operator in the district. Most of his land was put to grain. Atwood had also purchased the Henry Webster ranch, adjacent to his property. Local pioneer L. Cobb, for whom Cobb Canyon Road (today's Live Oak Canyon Road) was named, sold his properties, including the orchard, to Mr. and Mrs. Dehails from Beverly Hills.

From left to right, Beverly and Roger Ward and their cousins Sue and Larry ride Chubby, half of Fred E. Ward's workhorse team, which included a skittish Clydesdale named Ball. The family's small ranch was at the southwest corner of Sixteenth Street and Highway 99 in Dunlap Acres, which is the lower, west end of the community.

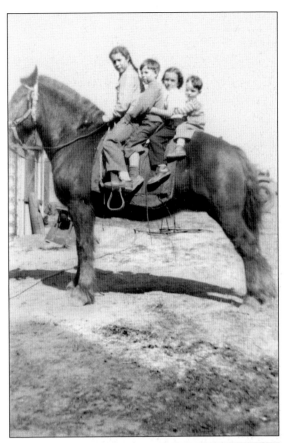

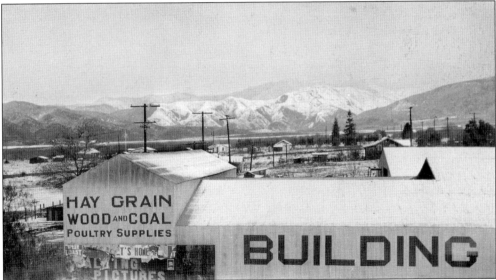

Holsinger's on upper Yucaipa Boulevard advertises its wares on its buildings in this photograph that also shows housing units, utility poles, the agricultural areas of the North and Middle Benches, and the beautiful snow-capped hills. An old West Coast Redlands Theater (later known as the Fox Theater) playbill can be seen in the window.

13

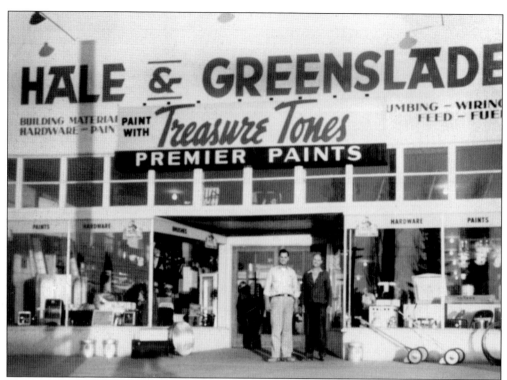

Elwain Hale (left) and Gordon Greenslade stand in front of their business on Calimesa Boulevard north of County Line Road. The two popular community leaders got their start across town at Holsinger's and opened their own store in the 1940s.

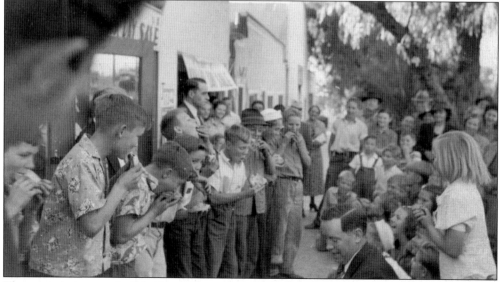

The community wasn't all business: Yucaipans also had fun together. In the photograph, a pie-eating contest is being held in front of Davis Market on Yucaipa Boulevard between California and First Streets.

From left to right, Lois Lamb, Betty Heller, and Coy Porterfield teach gas cooking at Hale and Greenslade's, which sold appliances.

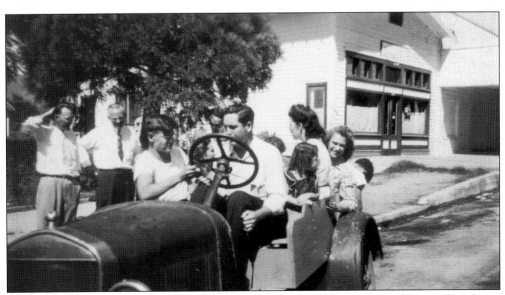

Members of the Parks and Lockwood families gather in the 1940s in front of Dan Dolen's home and store on Yucaipa Boulevard.

Grandparents Vet and Minnie Overly are pictured in 1943 when their grandson, Troy Benefiel Cole returns for a visit, fresh from boot camp. He was soon to leave on the USS *Silverbell*, stationed in the South Pacific. The picture was taken under the big tree at the Pass Schoolhouse on Cherry Croft Drive.

Cy Barnett is pictured with his sisters Barbara and Helen Barnett at the corner of Yucaipa Boulevard and Second Street. The Parks home, which would later become a bank, can be seen in the background along with the Yucaipa Farmer's Cooperative building.

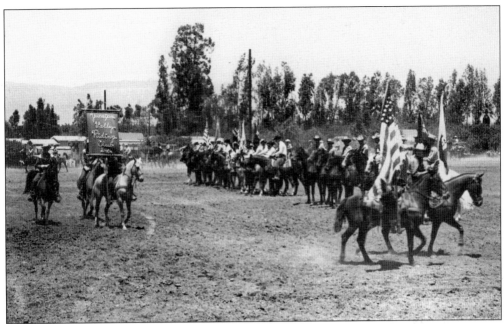

The Yucaipa Valley Riding Club was created in 1947. The club participated in local celebrations as well as in shows and events in other areas. In this photograph, the club members, in uniform, are taking part in the grand entry of a Colton Saddle Club gymkhana. Betty Jo and Savanna Palmers were flag bearers, Marge Vandiver carried the colors and club flag. Judy Bomgardner, Howard Barnes, G. Bigelow, George and Flossie Miehle and Natalie Gammey rode in the entry as well. The riding club fostered equestrian programs and fellowships.

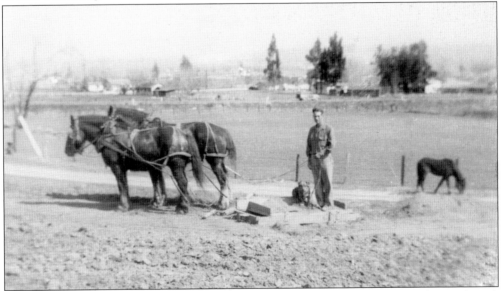

Paul Ward is shown in 1945 with horses Chub, Ball, and Tony in the background. The Ward ranch was along Highway 99 at Sixteenth Street in Dunlap Acres. Dunlap included many orchards, primarily peaches, plums, and walnuts. On one ranch, H. S. Stiles had harvested 535 pounds of cherries from one Early Richmond tree. The Early Richmond cherry is compared to the Royal Anne and Bing cherry and is known as the all-purpose cherry.

Nyna Vaught is pictured in the Big Brown House, as it was known in the 1940s. The house was located on the original Clyde Ranch (now Yucaipa Regional Park). Even before it was made a public park, the area served as a gathering spot for the neighborhood.

Edith Kerr Barnett stands with her son Cyril "Cy" Barnett, who graduated from the Merchant Marine Officers Training School in Alameda in 1945. Edith was known for her green thumb. She loved her flowers and plants so much, and grew them so successfully, that the family home could barely be seen from the street. She served as notary in the courtroom (the family living room) of her husband, Judge G. O. Barnett from 1935 to 1953.

Judge G. O. Barnett holds his granddaughter, Sharon Barnett. In the late 1920s, G. O. and Edith Kerr Barnett moved their family to the northwest corner of Yucaipa Boulevard at Second Street. G. O. —or "Pop" as his family called him—held Justice Court in the family living room from 1935 to 1953. He raised hogs, dry farmed hay for his horses, and kept the family milk cow in his big red barn behind the house off Second Street. This photograph was taken around 1943.

The home of G. O. and Edith Kerr Barnett on the corner of Yucaipa Boulevard and Second Street was versatile, serving as the location for the town's Justice Court as well as the office for their successful real estate and insurance business. On occasion, Judge Barnett was known to forego his usual suit and tie and hold court wearing his farmer's overalls. He was known to be dignified, fair, and kind-hearted toward those who came before him. Many times when he had a wedding to perform, Edith would serve as the witness and bake a wedding cake to boot.

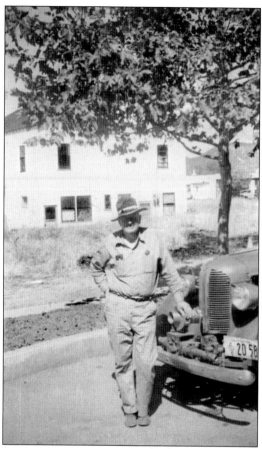

Ed P. Guthrie is pictured at the Avenue A fire station in the 1940s. Guthrie, who had been the assistant ranger since 1935, was in charge of the Yucaipa Forestry Fire Station. He retired March 1, 1944, under civil service regulations, as he was 70 years old. When Guthrie's replacement left for the U.S. Army later in the month, a petition was circulated to have Guthrie reinstated and a huge number of people signed it, but ultimately, Steven Gross took Guthrie's place in late April. The Guthries continued to live in their home adjoining the fire station, however. Notice the Odd Fellows hall in the background. It still stands today.

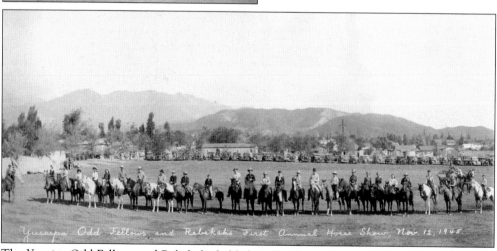

The Yucaipa Odd Fellows and Rebekahs held their first horse show on November 12, 1945, at Grange Park on First Street at Avenue B. The Y can be seen on Y Hill in the background. Queen Debbie Karr was crowned at a dance held on November 10. Her court included June Ward, Louella Webb, Gladys Curtis, Marge Vandiver, Norma Kerr, and Margaret Frisbee. The horse show included 22 events with races, costume contests, and classes—as well as the presentation of a pygmy ape from Borneo.

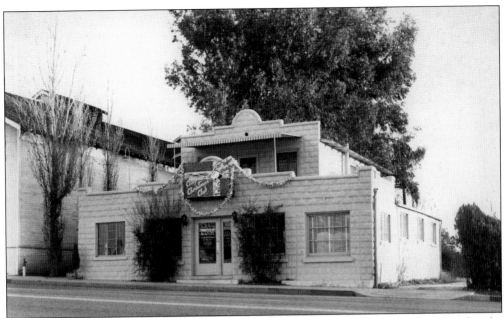

The Yucaipa Valley National Bank was the first financial institution in the community after the 1911 First Bank of Yucaipa City's charter and incorporation failed to receive approval. Herb Morrison opened this bank on January 2, 1947, after G. O. Barnett, Perry Beauchamp, Paul Whittier, and John Greven had submitted the application to the Federal Deposit Insurance Corporation, the Federal Reserve Bank, and the banking commissioner in Washington.

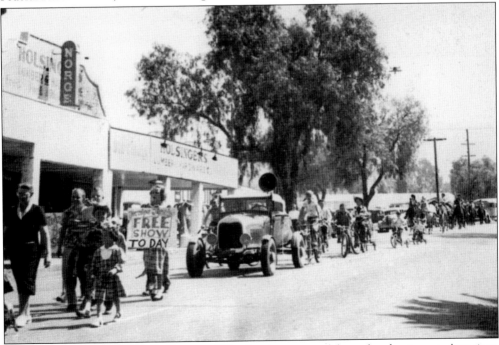

Parades were popular in 1940s Yucaipa. Whether it was to celebrate local veterans, American Independence, or the start or end of the school year, the entourage would move down Yucaipa Boulevard. This parade was held in 1948. Note the sign saying, "free movie day."

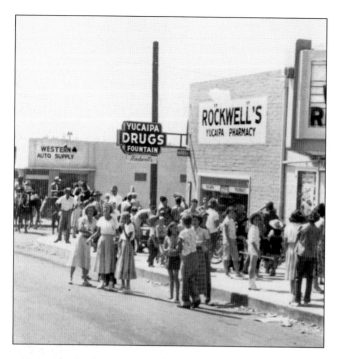

In 1947, the town celebrated the opening of Rockwell's Yucaipa Pharmacy on today's California Street. The pharmacy store was leased in the Pierce Building, which also included the Yucaipa Theatre. The Western Auto Supply stood across Avenue A on the same street. On the other side of the theater was the newly renovated *Yucaipa News* office, where the weekly local newspaper was published. That year, the population of the community was 2,017 families, for a total of 5,595 people. The census was completed by Earle Brothers Directory Services and included a house-to-house canvas of the area. The 1941 count had only counted residential water meters.

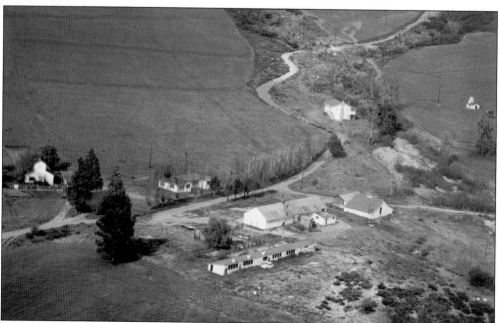

While downtown Yucaipa expanded with new businesses, the ranches and farms surrounding the commercial area continued to flourish. This photograph of the El Dorado Ranch shows the 1880s Thomas J. Wilson home above, the pig farm's slaughterhouse, the chicken and turkey houses (where McAnally's Egg Ranches got their start), barns, and homes. The ranch at one time included orchards, apiaries, and grain fields. Serrano artifacts, including ceremonial bowls and gaming stones, have been found on the property. The El Dorado Ranch is located on the North Bench at the northeastern corner of the community.

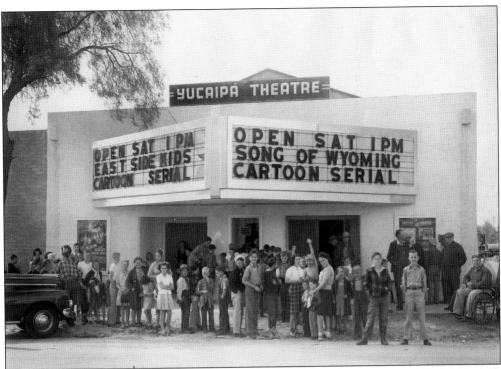

The Yucaipa Theatre opened in 1947 in the Pierce Building on California Street with H. W. "Red" Miller managing and his wife, Velma, running the box office. The marquee included fluorescent lighting. The films operated on Simplex projectors with Western Electric sound systems. The movies advertised on the marquee are the 1945 Eddie Dean western, *Song of Old Wyoming*, and 1946's *Live Wires*, starring Leo Gorcey. The theater was the only movie venue in Yucaipa.

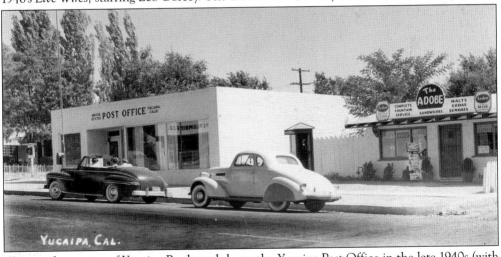

This southern view of Yucaipa Boulevard shows the Yucaipa Post Office in the late 1940s (with outdoor post boxes), one of the town's public telephone booths, and the Adobe Café. In 1945, Yucaipa's postal service, under postmaster Harold Rous, had expanded to include both second class service and rural route service. Hadley and "Pete" Burklow purchased the half-completed adobe building from Flora Lewis, finished the construction, and opened the café with a soda fountain and light lunches on the menu.

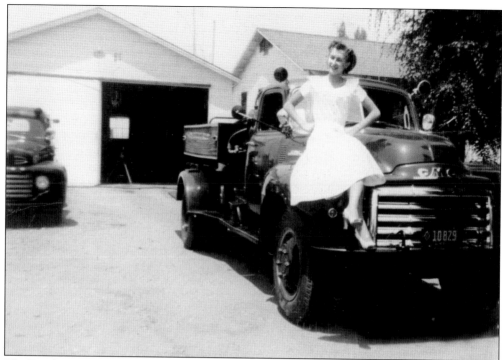

The Peach Festivals, which replaced the Yucaipa Apple Shows, started in 1947. That same year, the Miss Yucaipa Queen pageants began, organized by the Yucaipa Valley Chamber of Commerce. Colleen Gazzo was the first Miss Yucaipa. In this 1949 photograph, Sally Colas, sponsored for Peach Festival Queen by the crew of the Yucaipa Fire Station, perches on a Yucaipa fire truck in front of the Avenue A station house.

This 1940s photograph shows, from left to right, Ken Dowell; his mother, Imogene; and his brother Richard at Grandview Park. A housewife, Imogene raised her two children and was active in the school and PTA. After the boys grew up, she worked in the cafeteria at Yucaipa High School. Richard joined the U.S. Navy and went on to become a chemist at Hunt Foods, which became ConAgra.

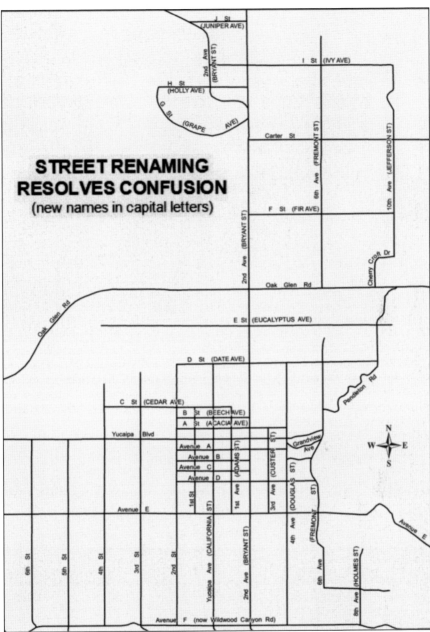

This map of Yucaipa shows the street renaming completed in 1946 by the Yucaipa Valley Chamber of Commerce. Most of the original street names had been changed in 1931, and many people were confused with roads doubly named as Second Street and Second Avenue. So alphabetical street names were changed to the names of trees and listed on maps in alphabetical order. A Street became Acacia Avenue and B Street became Beech Avenue. Numbered avenue names were changed to those of famous Americans: Second Avenue became Bryant Street, Sixth Avenue became Fremont Street, and Yucaipa Avenue became California Street. Numbered streets and alphabetical avenues remain unchanged, and that continues today even into the city of Calimesa with Avenue K and L. For the next decade, some residents would continue to express their frustrations with the address system with meetings and petitions.

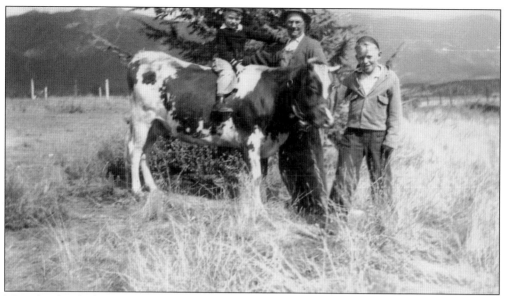

Most families had their own bovines for beef and milk well into the middle of the 1960s. Here Charles Benefiel sits on the family cow with grandfather Vet Overly and brother Troy Benefiel Cole at Casa Blanca Ranch. By the end of the 1940s, Yucaipa had grown considerably but remained firmly agrarian. In 1949, sixty-eight percent of the total value of the area's agricultural production was in chickens, eggs, turkeys, and rabbits. Local farms sold $5 million worth of eggs. Some 3,000 acres were planted in grain and hay, 1,300 acres in peaches, and 400 acres in citrus. An additional 1,000 acres were planted in a combination of cherry, apple, apricot, pear, and plum orchards. Sheep, beef cattle, hogs, and dairy cows also continued to be important to the economy.

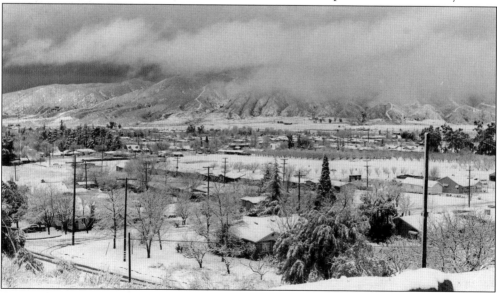

Yucaipa lies blanketed in snow, but orchards can be seen—along with new housing. By the end of the 1940s, the town had grown to an estimated population of 6,870, an increase of 520 percent since the first of the century. Four new church facilities were built around this time: a new First Baptist Church of Yucaipa, a new Yucaipa Methodist Church, St. Frances X. Cabrini Catholic Church, and a school at the Yucaipa Seventh-day Adventist Church.

Two

THE 1950S
LET THE GOOD TIMES ROLL

By the early 1950s, the Ocean to Ocean Highway had become Highway 99. It can be seen in the photograph with Yucaipa Boulevard veering off to the east. Peach orchards can be seen in the distance on the left. Homes and a handful of commercial enterprises dot the roadsides. The corridor would become Interstate 10 in the 1960s.

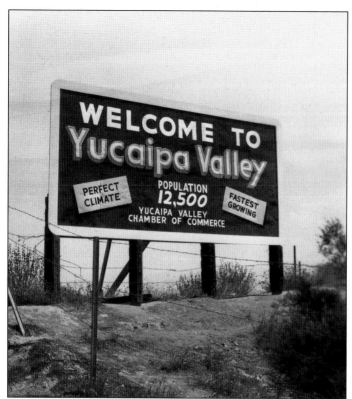

The Yucaipa Valley Chamber of Commerce continued to provide strong community leadership throughout the 1950s. This sign was located on Yucaipa Boulevard just west of the Highway 99 junction. The chamber served to meet Yucaipans' needs and desires, both directly and by presenting them to the San Bernardino County Board of Supervisors. With the chamber's encouragement and assistance, many new businesses opened and thrived in the 1950s. Some big plans, however, did not come to fruition, including the big sanitarium on the North Bench. The population increased dramatically during the 1950s.

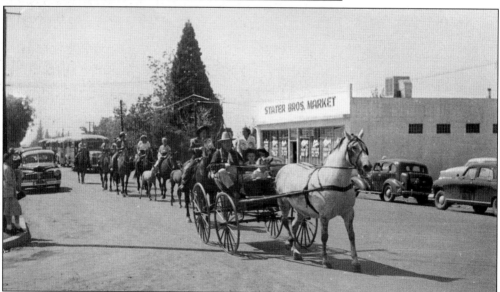

The Back to School Parade was held in September 1950, complete with horses, a wagon, ponies, and the buses the community had worked so hard to provide in the late 1940s. Constable Roscoe Deaton had started Yucaipa's bus line as the Yucaipa Valley Stage. The modern self-service Stater Brothers Market in the background had opened in 1946 on California Street between Avenues B and C. The Stater brothers called it their "lucky seventh" as it was the seventh in their growing chain of stores.

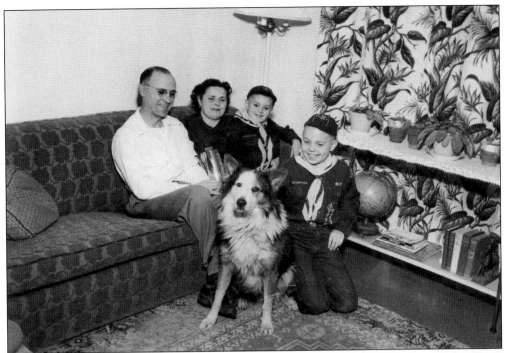

The Dowell family in 1950 are, from left to right, Kenneth R. Dowell Sr., Imogene Dowell, and their proud Cub Scout sons, Richard and Kenneth Jr. Ken Senior was a welder on Liberty ships in Santa Monica during World War II and continued as a welder with Food Machinery and Chemical Corporation, which built amphibious landing craft. He was active in the Masonic Lodge, where he received the Hiram Award. Ken Jr. later served as the director of nurses at Patton State Hospital. He retired after 39 years and is involved in the Fellowship Lodge.

Yucaipa Elementary School's first graders enjoy an Easter treat in 1954. Pictured with the students are mothers, from left to right, Julia Moore, Polly Gross, Barbara Arnett, and Wilma Tellis.

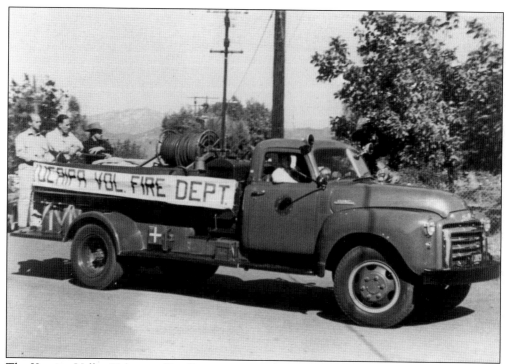

The Yucaipa Valley Volunteer Fire Department took part in the Fourth of July parade in 1960. The volunteer fire department was organized in 1946. After a call to the men in the community, Constable Elmer Bise, Wilford and Elmer Patterson, and a few others took leadership roles in the effort.

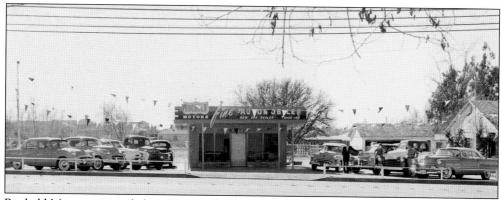

Rocheld Motors operated along Yucaipa Boulevard from 1950 to 1960.

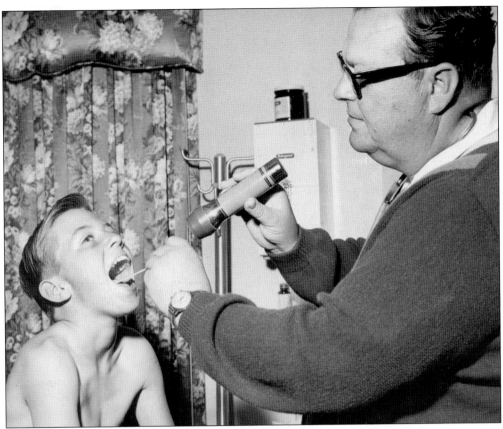

Dr. Alton Edwards checks the throat of 12-year-old
Rick Hodgins, who was getting his medical check
for his third year in Yucaipa Little League. Gerald
Rutten, M.D., later opened offices on Fourth Street
for his general practitioner and surgeon practice.

At 9:22 a.m. on February 24, 1951, Marsha
Kay Renshaw (pictured here in the first
grade) was the first baby born at the newly
opened Yucaipa Hospital. The hospital
added a 12-bed annex in 1953.

Betty Martines stands in front of the original Yucaipa Animal Placement Society (YAPS) shelter located on her property at the northeast corner of California Street and Avenue A. YAPS operated for many years as a phone network, providing placement for homeless dogs and cats.

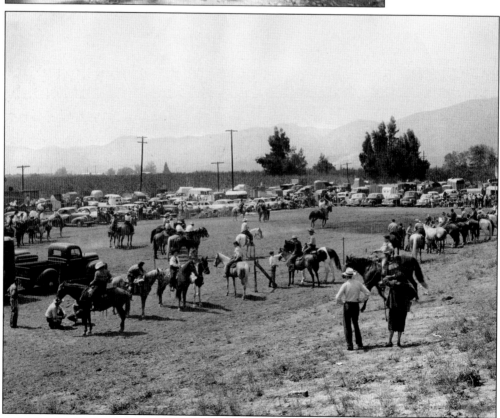

This Yucaipa Valley Riding Club horse show was held on Seventh Street where the Seventh Street Park's Teen Center and the swimming pool were later located. Notice the orchards and trees across the street where housing tracts are now located.

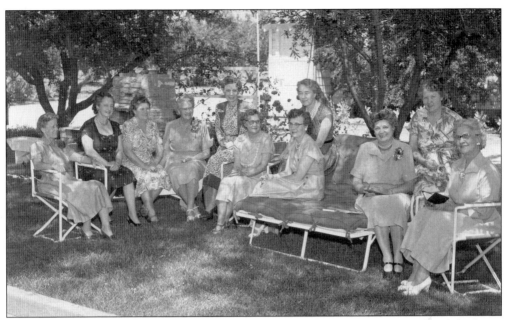

Members of the Yucaipa Woman's Club gather in this c. 1951 photograph. Pictured are Edith Sherer, Marion Lewis, Carla Woods, ? Miller, Myrtle Crane, Edna Green, ? Dwignell, Ordell Cariven, Edna Todd, Esther William, and ? Wilkershum. During the 1950s, the Yucaipa Woman's Club contributed greatly to the preservation of the Yucaipa Adobe, then known as the Sepulveda Adobe.

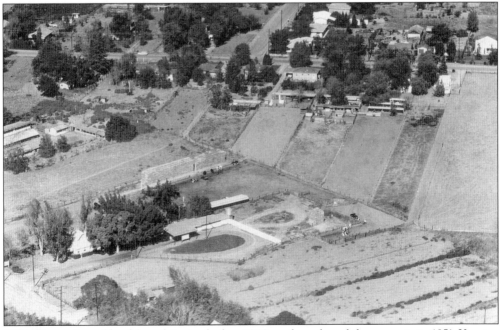

Oliver Brown leased land for a dairy in the late 1940s and purchased the property in 1951. Yucaipa Valley Dairy was located at 1514 Old Highway 99 in Dunlap. Brown and his wife, Ruth, started with 13 cows and built a major business marketing their milk products, which included ice cream, cottage cheese, and the small cartons of milk drunk daily by area schoolchildren. Yucaipa Valley Dairy continued to operate until the 1970s.

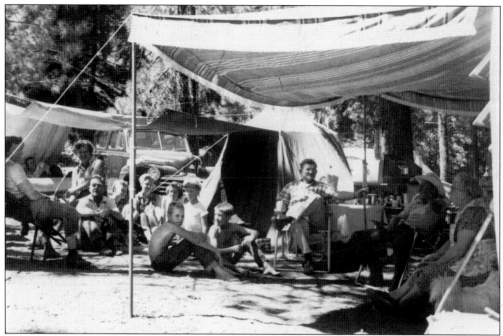

Yucaipans would often cool off during the summer by camping in the local mountains. In this photograph, Yucaipa families (including some members of the Yucaipa Valley Riding Club) gather around their campsite at South Fork above Barton Flats. There was not air conditioning at the time.

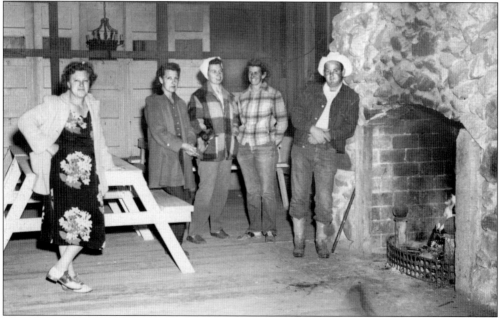

Seen from left to right, Dora Courvoisier, Vera Spurlock, Donna Beaver, Marge Vandiver, and William Beaver relax in the Wildwood Lodge in April 1954. The lodge was a popular event center for area residents, especially for dances and holiday celebrations. While the lodge burned down in the 1960s, the stone fireplace remains standing in Wildwood Canyon State Park.

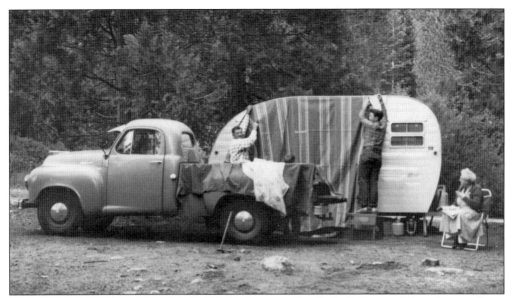

In this photograph, another family sets up camp at South Fork. Located less than an hour northeast of town on Highway 38, South Fork remains a popular camping destination with Yucaipans today.

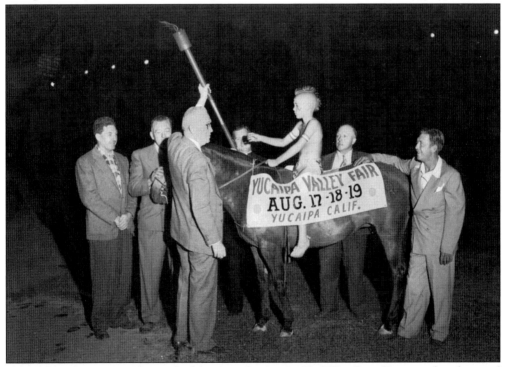

Yucaipa has always enjoyed a good celebration. On August 18, 1951, a Pony Express rider advertised the Yucaipa Valley Fair. From left to right are Medrick M. Masters, Ralph Davenport, McIntyre Fairies (holding the torch), eight-year-old Amos "Buddy" Palmer (mounted on Ginger), A. F. Lund, and Paul Atherton. Fr. John Tahany, from St. Frances X. Cabrini Catholic Church, can be seen behind Buddy's hand. (Brink.)

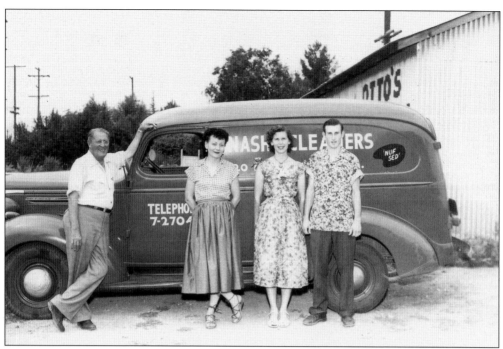

John Nash opened Nash Cleaners at 120 East Yucaipa Boulevard in 1950, and the shop remained in business until 2008. Pictured with him are Ethel and Virgil Lollis, who would later take over the operation.

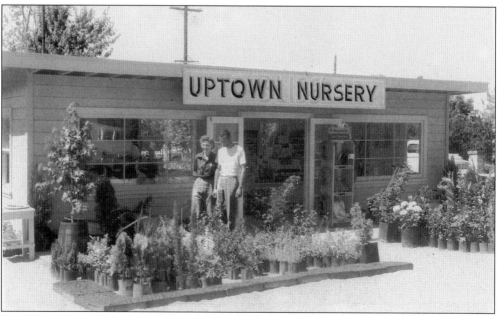

Harold and Lucy Bliss operated their Uptown Nursery at the corner of Yucaipa Boulevard and Second Street, seen here around 1955. The Blisses partnered with E. A. Cole in 1957 to open the Bliss and Cole Nursery at 34017 Yucaipa Boulevard. Bliss first operated the nursery from his residence on California Street near Avenue F and opened the Second Street site in 1952. Prior to going into the nursery business, Cole had owned the Western Auto Supply for eight years.

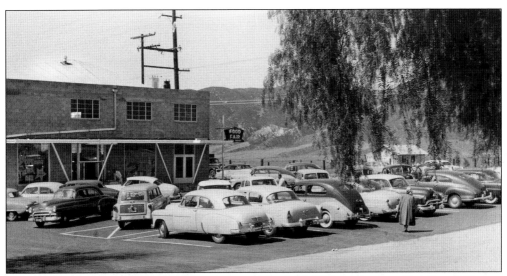

Food Fair Super Market held its grand opening on March 20, 1955, on the site of Lyle Lane's Texaco Service Station at the southwest corner of Yucaipa Boulevard and Fourth Street. The store offered 8,800 square feet of floor space, 34 parking spaces in front, and 35 spaces on the side. The opening was a two-day celebration with free orchids, baskets of food, coffee, cake, and ice cream.

Food Fair co-owners Dick Lammers and Frank Hughes prided themselves on selling only high quality choice Manning beef. Each Food Fair employee knew his or her specialty. The top floor of the building—constructed by John Knarr—featured a meeting hall/ballroom, which was also popular. The Yucaipa Elks Lodge No. 2389 first met upstairs.

L. Seth Lusby is selling Milton Gair a Willys Jeep Station Wagon at his popular business. Lusby also owned the Richfield gas station, a Volvo dealership, and an auto repair business at the northeast corner of California Street and Avenue C.

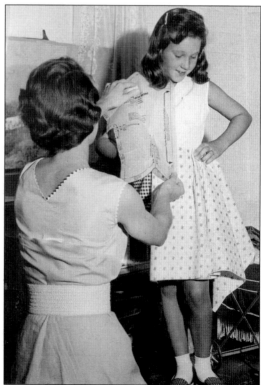

Sharon Rupp gets fitted for a back-to-school outfit in 1956. The pattern and fabric may have been purchased at Brock's Yardage.

The concept of unifying the local schools into one district led to many meetings in the mid-1950s. Discussions often focused on the practicality of uniting Yucaipa's and Dunlap's elementary schools to create a new, local school district separate from the Redlands School District. Discussions on the feasibility of creating a separate school district started in the fall of 1955 when public hearings were held following the submission of a 770-signature petition to the County Committee for District Organization. The Redlands High School District challenged the effort, but the new Yucaipa Joint Unified School District was established by election over its objections in June 1963.

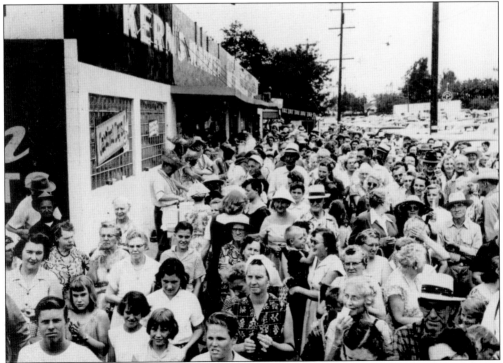

June 1, 1956, was a big day when Kern's Market opened on Calimesa Boulevard across town from other popular stores.

A Yucaipa Boy Scout meeting was held on a Sunday in March 1957. At the time, the population of the community was estimated to be 12,000 that year—up from 2,500 in 1945. Some 2,800 new homes had been added to Yucaipa during that 12-year span.

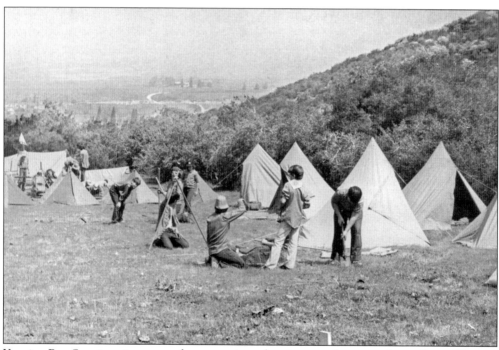

Yucaipa Boy Scouts enjoy an outdoor camping adventure on the mesa above Camp Hunt in Wildwood Canyon. The site became a Boy Scout camp in later years. Another popular activity in the 1950s was the apple box derby down Yucaipa Boulevard. In 1957, Randy Skyberg and Jeannie Ward won the derby in their wheel classification races. The course was eventually moved to Avenue E, and the derbies continued well into the 1970s.

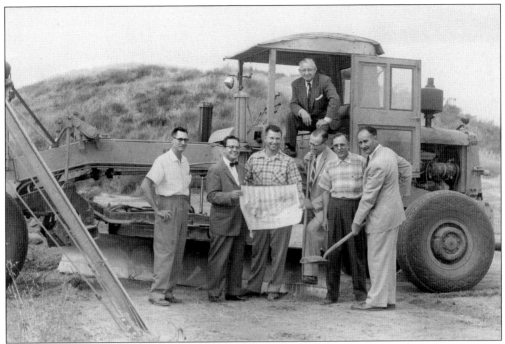

While the land for Grandview Park was dedicated by the Redlands-Yucaipa Land Company and Yucaipa Water Company No. 1 in the first decade of the new town site, it wasn't until the 1950s when the Yucaipa Valley Chamber of Commerce's efforts led to the park's first real improvements. The water company finally deeded the property to the Yucaipa Recreation District that year. Pictured are, from left to right, Ralph Gillette, San Bernardino County supervisor Dan Mikesell, recreation director George Leja, John Fairweather, Jay Holman, and chamber president William L. Newton, who wields the shovel.

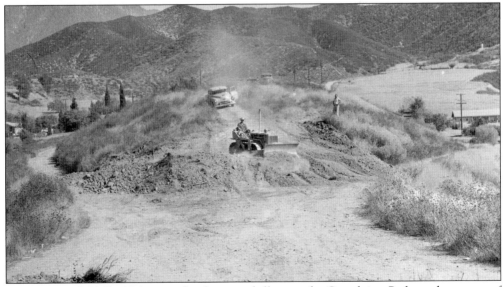

It is 1956, and Clifford Martin is leveling two hills to make Grandview Park, at the corner of Yucaipa Boulevard and Fremont Street. The community flagpole was also installed that year. Today the area is known as Flag Hill Park.

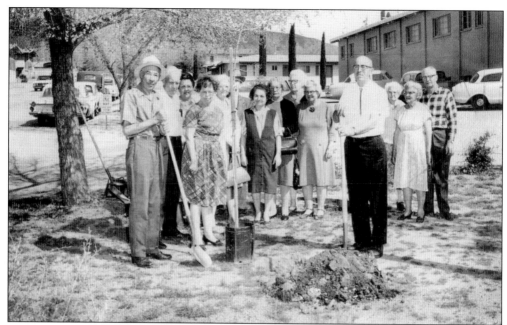

Celebrating the planting of an Asian pistache tree at the new Grange Hall are, from left to right, members Lloyd Green, Ulysses and Betty Rose, Mabel Clark, Lois Stringfellow, J. E. Sudlow, Mary Holt, Anna Augustin, Gale Christie, Corda Woods, Luella Sudlow, Edna Green, Ernest Fidler, and George Lasater. Also present were Mary Stater (charter member of the Grange), Ed Eavers, and George Stringfellow.

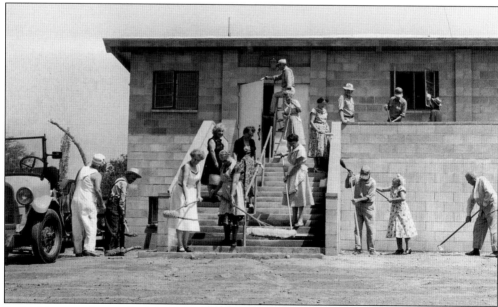

In this photograph, members of the Yucaipa Grange are cleaning the new Grange Hall (dedicated 1954) at the corner of Second Street and Avenue A. The Grange, established in 1935, was a major force in the community for many years. One of the causes taken up by Grange members was an opposition to the proposed change from three-digit addresses to the county's five-digit system in the 1950s, which continues today.

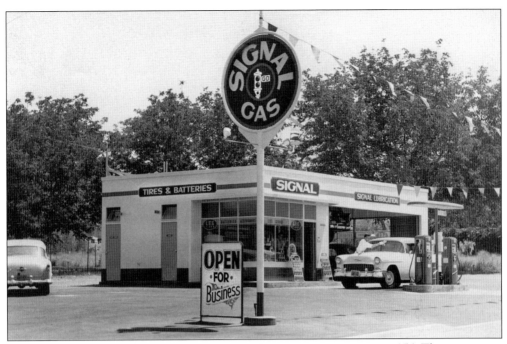

Leo Anderson celebrated the opening of his Signal Gas station in August 1956. The station was located at the northeast corner of Fourth Street and Yucaipa Boulevard, where the Jack in the Box was constructed in 1985.

Hal and Florence Sherman (shown here with Gertrude Fuchs, right) operated the Park and Eat restaurant at 34409 Yucaipa Boulevard. Restaurants were popular in 1950s Yucaipa, but beer taverns were not. One application filed by a prospective tavern-owner prompted a protest petition signed by 2,000 concerned local residents. The Park and Eat is now Sports Shack, operated by Pat and Howard Reeves.

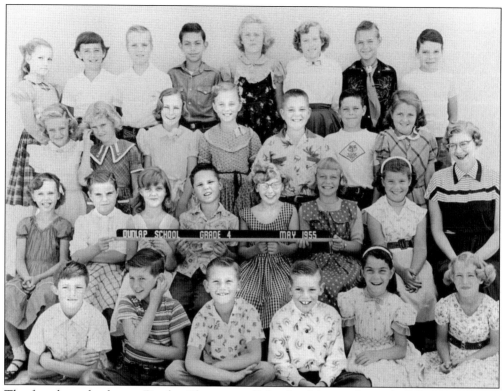

The fourth grade class at Dunlap Elementary School celebrates the end of the 1955 school year together. The following year, the Yucaipa Joint Unified School District officially included Calimesa students, who up to that time had been attending through an inter-district agreement with Riverside County.

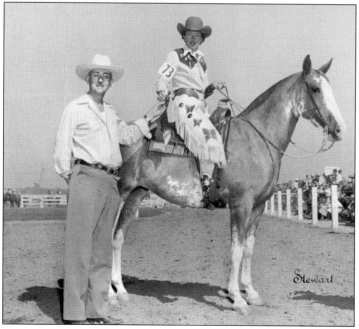

Vernon and Marian Hunt bought the area known as the Old Lou Morris Ranch in the 1930s and established the renowned Hunt Ranch. Vernon also operated his V. P. Hunt trucking company from Redlands. The Hunts were important people in Yucaipa Society. At one time, they owned most of the land that is today's Wildwood Canyon State Park. Marian was an avid equestrian. In this photograph her husband, Vernon, presents her with winning ribbons.

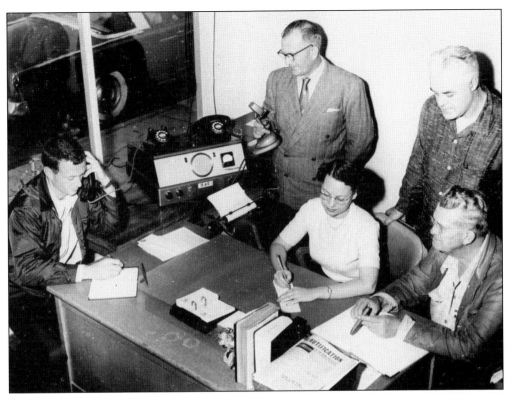

Constables provided police services in the early 20th century, but in 1947, county sheriff James W. Stocker established a Redlands substation. In 1955 he assigned Sheriff Frank Bland to work out of Yucaipa. The deputy operated with one phone on a small desk in the Yucaipa Fire Station. On February 25, 1957, the first sheriff's station opened at 35077 Yucaipa Boulevard. Pictured in the late 1950s are, from left to right, Deputy Willard Farquhar (on the phone), Lyle Lane (holding the radio microphone), station secretary Jean Cragg, Deputy Gene Prince, and Lt. Henry Richardson.

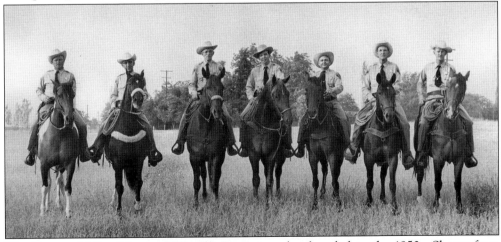

The Yucaipa Valley Mounted Sheriff's Posse was also founded in the 1950s. Shown from left to right are Al J. Hull, Juan Hernandez, Manuel Silva, Gene Estopinal, Earl Mull, posse commander Jay Sarrett, and Mickey Lynn. Here they are preparing for a big show in September in Wildwood Canyon.

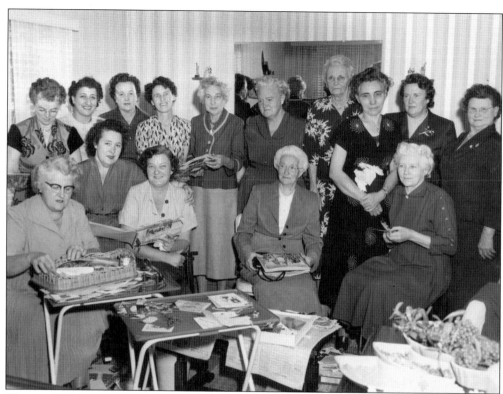

This is a 1950s meeting of the Unusual Club, which met at Julia Moore's home at 35264 Avenue A. Seated in the first row are Elizabeth Beswick, Ruth ?, unidentified, Mattie Pierce, and Veda Emery. In the second row are Jay Farrar, Julia Moore, Leona Blake, Helen Garland, Jessie Jackson, Alice Newton, unidentified, Honey Nelson, Kathern Moore, and Jeannette Robinson. (Photograph courtesy of Jackie Deaton.)

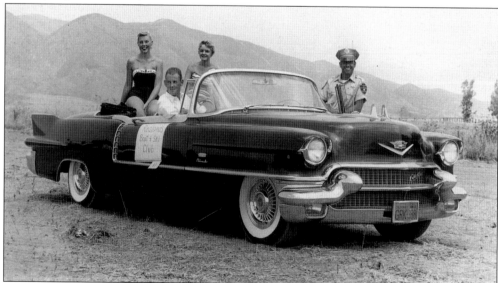

Constable Jim Martines (right) drove the new 1957 Cadillac convertible with the Yucaipa Queen (left) in the parade. They are parked at the northwest corner of Yucaipa Boulevard at Fourth Street.

Honey production in Yucaipa started in the 1860s when the first pioneers established apiaries. In that decade, James Waters shipped the product of 100 stands of bees by wagonloads to mines in Arizona. Production continued into the 20th century when a railroad stop was planned along Bryant Street to help ship the honey around the nation. In this photograph, Walter Wride is checking his beehives. William and Myrtle Raine were major honey producers for over 30 years. In 1957, Bill built a warehouse on their property on Avenue H. He sold the honey products to the Miller Honey Company in Colton.

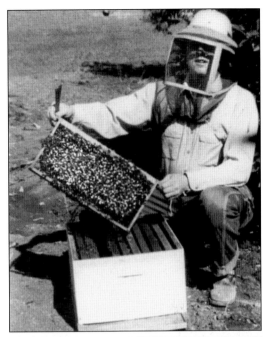

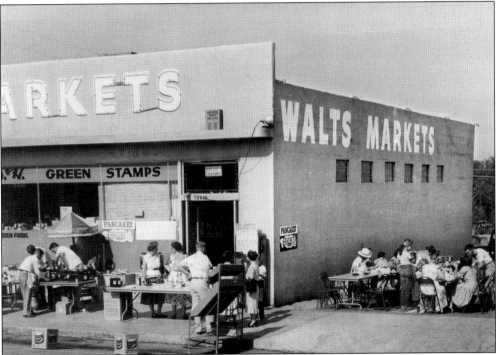

Walt's Market was a popular shopping venue on California Street. Walt Swint managed the food emporium. When the Staters had sold the store in 1951, they sold it to Swint and his partner Vic Blakken. Swint merged with Stater Brothers Markets in 1958 when Staters built its new supermarket at 34583 Yucaipa Boulevard. Stater Brothers at that time had grown to 20 stores. Most of Walt's Market personnel became Stater Brothers employees. The Matthews home was removed to make way for the store on the boulevard.

Yucaipa High School was established in 1958 with a sophomore class at the 20-acre Sixth Street junior high school site built by Redlands School District in 1951–1952. Five acres were also set aside as a park site. The high school shared the Sixth Street campus until the new high school was constructed.

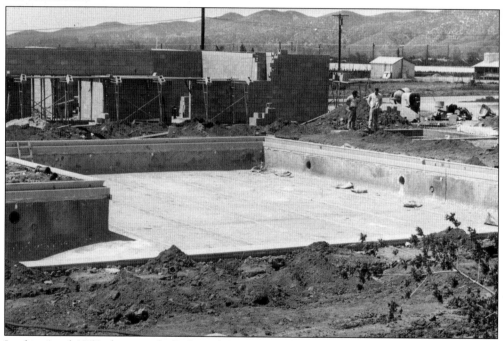

In this April 1957 photograph, Park and Recreation director George Leja and engineer Earl Dakin inspect the wading pool and buildings under construction as part of the new Seventh Street pool complex. In an 1956 election, Yucaipans had voted to authorize $88,000 in bonds to fund the complex and improvements of existing parks. The pool opened June 15, 1957, when Tillie Foster—clad in a bathing suit—cut the ribbon. Students could swim for 25¢ a day or $10 a season.

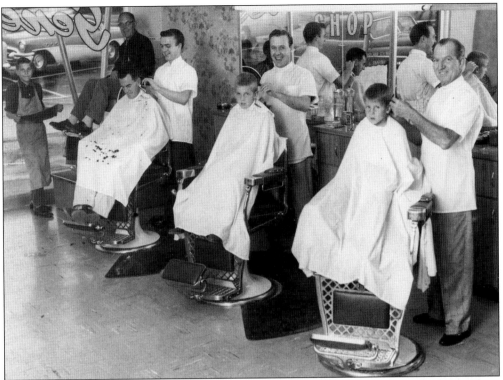

Gene's Barber Shop was located in the Fourth Street Shopping Center. Gene is pictured here with fellow barbers Dick and Ben.

As properties changed hands, existing buildings were often moved. In this photograph, The G. O. Barnett barn is being moved from Second Street and Yucaipa Boulevard to Cy Barnett's property at the lower end of Oak Glen Road. The Yucaipa Valley Planning Association led a committee of local residents from the five areas—North Bench, Middle Bench, South Bench, Dunlap (Lower Bench), and Pine Bench (Oak Glen)—of the community who went into action in 1956 to help guide growth and assist in settling zoning issues.

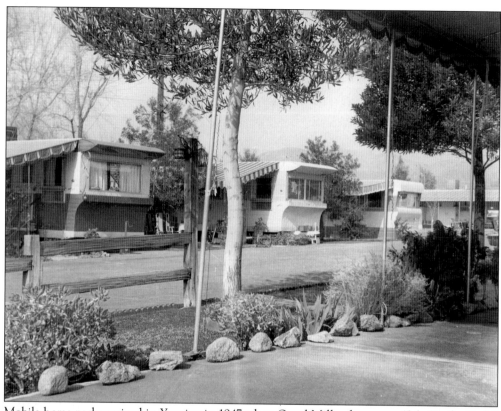

Mobile home parks arrived in Yucaipa in 1947 when Orval Miller, known as "Mr. Trailer Park," laid the cornerstone for the 20-space Yucaipa Valley Trailer Park on Fourth Street. Sixteen more trailer parks were built in the following 12 years. Pictured here is the 25-space Hitching Post Trailer Park, built by Edwin D. Majestic, and opened on November 10, 1955.

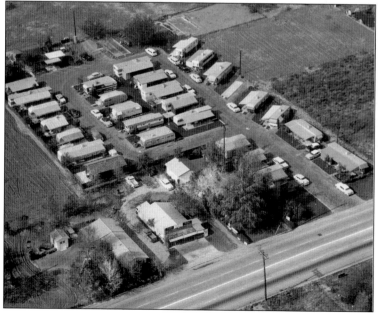

This aerial view of Hitching Post Mobile Home Park reveals that it was constructed on former farmland. At lower center stands the Boulevard Market. Four-lane Yucaipa Boulevard runs across the lower right of the photograph. The community had requested a four-lane *divided* boulevard, but in 1952, the San Bernardino County supervisors rejected that plan as too expensive.

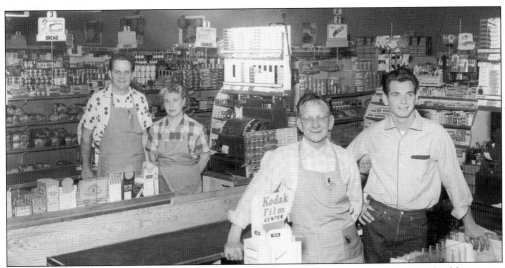

Walter and Ralph Davis moved the Davis Market down the boulevard to a larger building next to the co-op building in 1952–1953. Ralph closed the market at the end of 1957. Walter had been in the grocery business for 30 years. The Serv-U Market opened in the same location in January of 1958 and flourished in the same location. The supermarket included a coffee shop. Pictured are (front row) Serv-U proprietor John L. Schmitt (left) and his son Jack; (back row) Schmitt's son-in-law Don Hoy and John's wife, Nina Faye. In 1979, Ralph bought back the building and turned it into a used furniture and antique store.

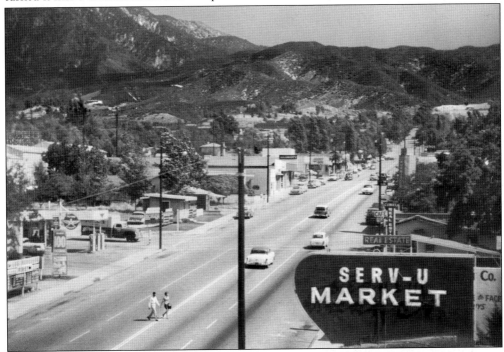

Taken from the roof of the Serv-U Market store, this photograph of Yucaipa Boulevard looks east up the boulevard and reveals businesses lining either side of the road. By 1958, Yucaipa boasted 3,503 permanent homes and an estimated 500 trailer residences. In 1956, Edison had added street light poles (seen here) to Yucaipa's primary streets.

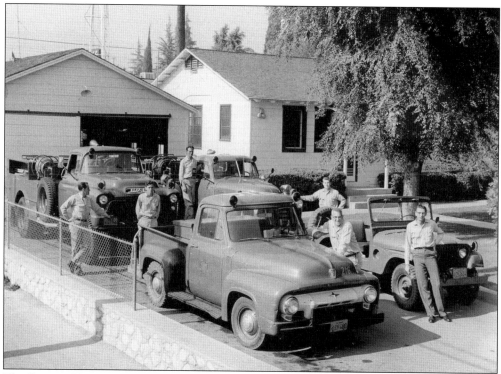

The Yucaipa Fire Protection crew is pictured in 1959 in front of the Avenue A station. From left to right are Jack Tilley, an unidentified firefighter with hands behind his back, Warren Keehnel on the running board, and John Pogue, who later became a police sergeant. In front of him next to the pickup is Art Balsom, and leaning on the Jeep is Bob Dalgity.

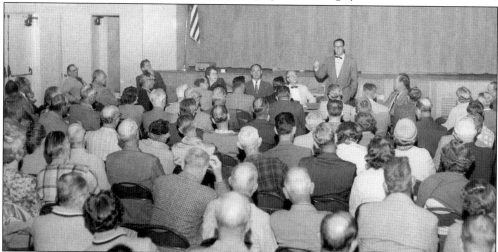

Toward the end of 1957, a tax protest meeting organized by the chamber of commerce brought a large crowd that jammed the Yucaipa Elementary School auditorium. Speaker James Smith provided the audience with legal advice and information about tax procedures. Many residents paid their property taxes under protest and the chamber led a "tax fight" with Jim Holden, John Gross, and Chet Crilly at the helm. The county assessor ultimately opened an office in Yucaipa to resolve the issues.

Walt and Dorothy Morbitzer pose in front of their very popular Morbitzers' Poultry Barn restaurant on Yucaipa Boulevard in Dunlap Acres. They opened their business in 1957.

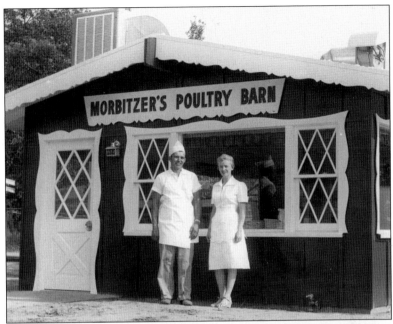

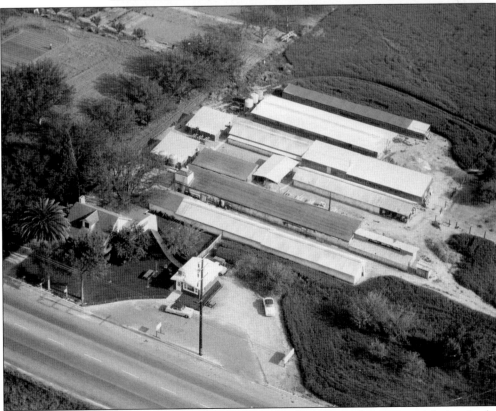

The Morbitzer home, restaurant, and chicken ranch are all visible in this 1950s aerial view. In the 1950s, a total of 19,674,583 dozens of eggs were also sold throughout the southland. The community egg ranchers produced a combined $7.4 million in chicken-related income a year.

Viewed from left to right, Elmer Patterson, Yucaipa Junior Marines Cadet Jim Gilliam, Cadet Kenneth Patrick, and Jim Martines work on a Flag Hill Park addition commemorating the town's World War II veterans.

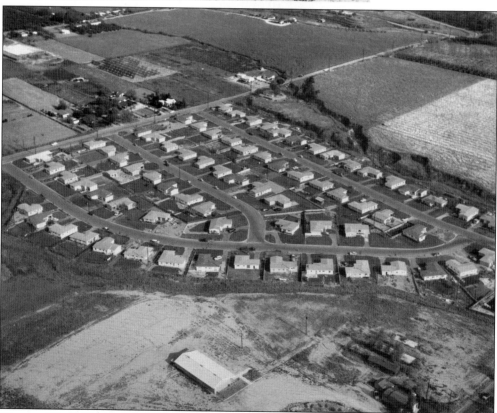

The post-World War II era brought a building boom with Yucaipa's first subdivisions. Pictured is a group of new Fiesta homes called Mountain View Heights on the west side of Bryant Street, seen toward the top of the photograph. Streets in the subdivision include Mountain View, Vineyard, and Velardo. The three- and four-bedroom homes sold for about $9,000 apiece.

Three

THE 1960s

HOMETOWN HAPPINESS

Yucaipa High School students proudly carry their town's name. In 1960, the preliminary census stated Yucaipa's population was 13,092, but that did not include residents along Highway 99. The Yucaipa Valley Chamber of Commerce estimated the full population to be closer to 20,000.

An early 1960s Christmas parade moves along California Street. Notice the Yucaipa Library and the Odd Fellows Hall on the east side of the street. The street sign to the right, donated by Leroy Davis, is now at the Mousley Museum. It was donated to the town by Leroy Davis.

Dr. Roy Mountain's veterinary clinic can be seen in this view from the south side of Yucaipa Boulevard between Fifteenth and Sixteenth Streets.

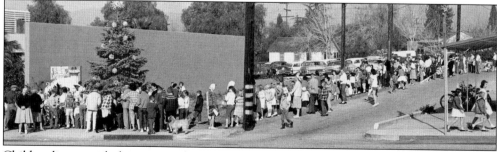

Children line up with their parents for a visit with Santa next to the town's Christmas tree, which was decorated each year. The tree stood on the north side of Yucaipa Boulevard in the 35100 block east of California Street, at the original Citizen National bank site.

56

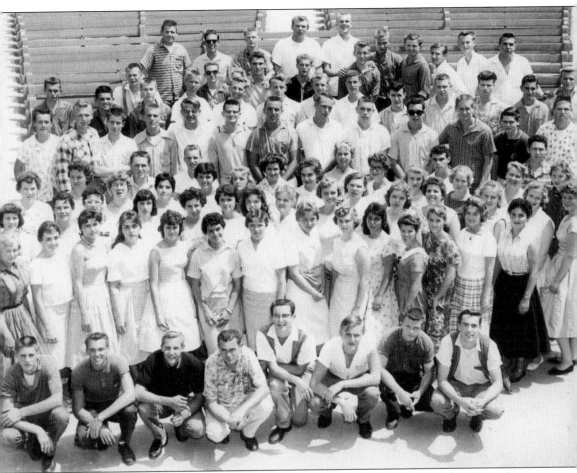

These 115 students, pictured in 1960, were some of the last Yucaipa students to graduate from Redlands High School. With the construction of Yucaipa High School, Yucaipa students would no longer be "going down the hill." Pictured from left to right, the students are (first row) Gary Roper, Sidney McLaughlin, Steve Robbins, George Atkeson, Milton Houghton, unidentified, unidentified, and Harry TerBest; (second row) Melody Kruse, unidentified, Fredrica Buse, Pat Oleary, Barbara Taylor, Penny Smith, Patty Edwards, unidentified, Myrna Hammond, Barbara Oppelt, Silvia Cambell, Dorma Furtado, Sandy Woods, and Marilee Walters; (third row) Sharon Barnett, June Carter, Roxanne Cremer, Carolyn Cobb, JoAnn Scull, Sydney Green, Monna McEvers, Mary Melton, Very Jean MacMillan, Linda Tapley, Lynn Fischer, Ann Stoker, and unidentified; (fourth row) Donna Memory, Barbara Declark, Carol Hayden, Carol Wilcox, Carolyn Harvey, Lynn Marquis, Sylvia Wilson, Diane Wells, Judy Compton, Jean Solberg, Judy Bacon, Sue Jones, Janette Surber, unidentified, Daylene Weaver, and Katie Knotek; (fifth row boys) unidentified, Amos Palmer, Lynn Ellsworth, and John Page; (sixth row) Thomas Debbs, unidentified, Randy Bauer, unidentified, Robert Combs, unidentified, John McCoy, Warren Bliss, Charles Irvin, Ed Ham, George Carter, Rudolf Feimer, and Delbert Turner; (seventh row) Dave MacKewen, Darrell Gilman, Larry Deaton, Jim Rippy, Ron Weaver, Tommie Harshman, John Ken Willina, Tom Nall, Tom Pilkkington, Richard Henderson, James Gillam, and Gary Schelon; (eighth row) Jim Killingbeck, Fred Wallace, unidentified, Jim Bell, Jim Studer, Jim Cansler, Sonny Shewmaker, Jack Lucas, Marshall Magnuson, and Dan Yingst; (ninth row) unidentified, Gary Lockwood, Arthur Smith, Malcolm Weaver, and Dave Beebe.

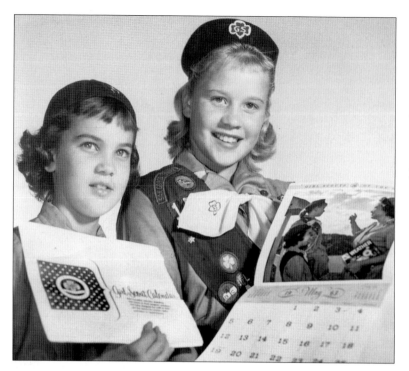

Girl Scouts Mary Ann Kelley from Troop 73 in Dunlap and Debby Walton of Troop 119 in Calimesa advertise their calendar titled *Looking to the Future* in November of 1962.

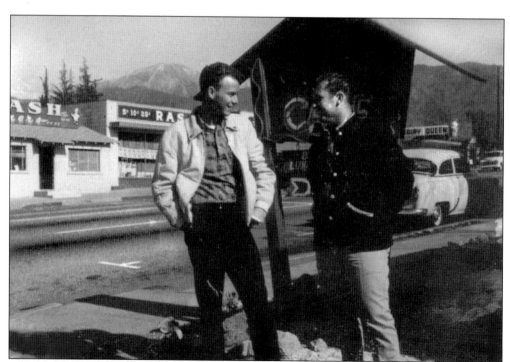

Mike McCort and Alan Miller hang out uptown in front of the Adobe Cafe in this *c.*1960 photograph. Notice Nash Cleaners, the Rasco store, and the Dairy Queen in the background.

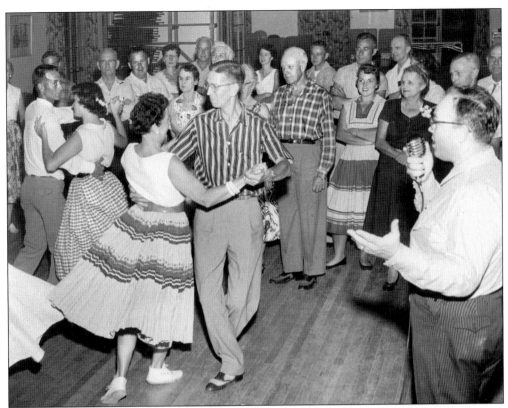

Walt Baumann calls for the Yucaipa
Square Dance Club at a dance held
in the Yucaipa Woman's Clubhouse.
At times, the club would have 200
members and guests at their gatherings.

Floyd and Lois Crosby opened their new
fabric store at 35077 Yucaipa Boulevard
in 1964. Today Floyd is Yucaipa's poet
laureate, and Lois is a longtime member
of the Yucaipa Woman's Club and
Philanthropic Educational Organization
(PEO). The Crosby's yardage store was
a popular business for many years.

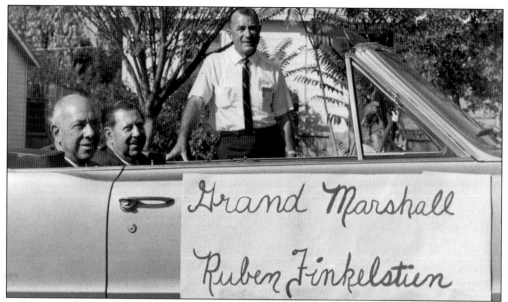

Ruben and Lester Finklestein were the grand marshals of the Yucaipa High School Homecoming parade in November 1965. Their name, however, had been misspelled. The Finklestein brothers, through their foundation, donated the land where Yucaipa High School and Crafton Hills College are located today.

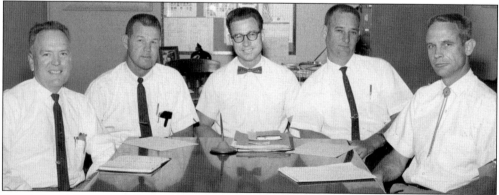

From left to right are the following: school principals Les Becker and Worden Nollar, superintendent Mel Powell, and principals Ham Sheppard and John Brandstetter, shown in 1962. In the late 1950s, the district had projected an 8 percent growth rate at the elementary level, however, the growth in the 1960s was primarily at the secondary level. The demographics of the community had changed: in addition to being a family residential area, Yucaipa became a retirement community. The many trailer parks and smaller apartments brought people whose children were already grown.

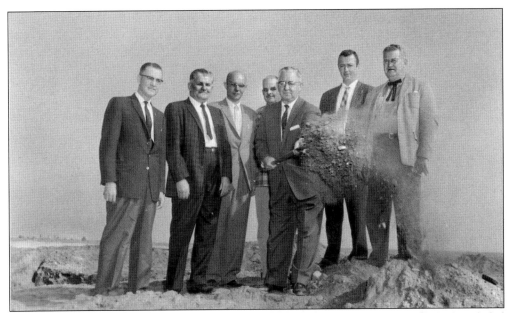

Breaking ground for the new Yucaipa County Building at 34282 Yucaipa Boulevard, which included the sheriff station, are, from left to right, Henry Richardson, Willard Farquhar, Wesley Break, Blackie Wilshire, Judge Bill Clark, and two unidentified gentlemen. The new station opened in the early 1960s. A resident deputy, Sid Herbert, had worked on an around-the-clock on-call basis with Constable Jim Martines since 1955.

Young Tom Ziech stands here in the early 1960s with his dog, Poncho, next to the Yucaipa Youth Center, which had been a major community project in 1948 and 1949. Funds for the Youth Center were provided by the proceeds of the Peach Festival and donations from John Greven and Paul Whittier. In 1951, Faith Lutheran Church bought the center and turned it into its first church building. The smaller building was used for Sunday school. Both buildings have since been demolished.

The sign in front of Jerry's Richfield on Yucaipa Boulevard says the station has sold out of gas, but its service bays are open.

The Kirkland drilling rig is in business on August 7, 1961, digging a water well on Sixth Street. In 1960, a Stanford Research report stated that the community was consuming water faster than it was replenishing its reservoirs, with an overdraft of 4,000 acre feet per year from the Yucaipa Basin. The decade brought much litigation over water issues.

The Floyd F. Ward Insurance Agency is well staffed on March 23, 1961, with, from left to right, secretary Linda Robinson, receptionist and office manager Jerry Ward, and field representative Roy Goodwin.

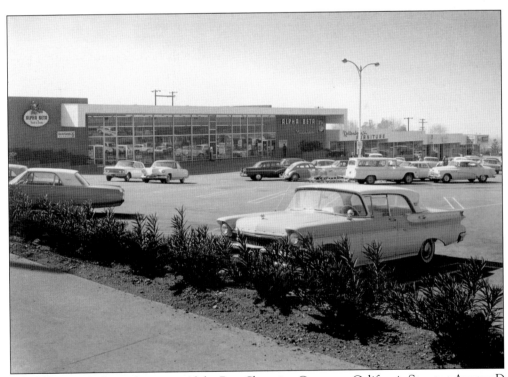

This photograph shows the active Alpha Beta Shopping Center on California Street at Avenue D in the early 1960s. The center was built on a five-acre citrus orchard owned by Norton Sturdevant and family, who were paid $11,000 an acre. The Alpha Beta chain started in 1910. The building later became Sail Discount Drug Center, which it remains today.

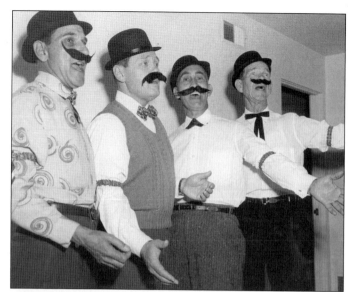

The Gay 90s Revues in conjunction with the Yucaipa Valley Chamber of Commerce were major theatrical events in town from 1962 to 1968. Pictured in the first show in 1962 are the Gay 90s Quartet of Wes Vaughn, Dave Presley, Lou Perkins, and Floyd Jones.

Don Rose from the Yucaipa Valley Chamber of Commerce (far left) and school superintendent Merryl Powell (far right) give kudos to, from left to right, assistant director Virginia Kriwanek, Doc Parker (who played Diamond Jim), and producer-director Anna Lavaroni at the finale of the first Gay 90s Revue in 1962. The group raised $19,000 over the years for the Yucaipa High School Scholarship Fund.

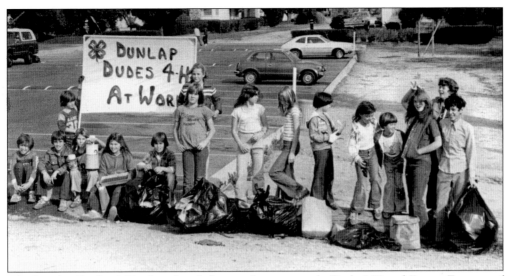

The Dunlap Dudes 4-H take a break from picking up trash. Both 4-H and Future Farmers of America have long been important youth activities in the community.

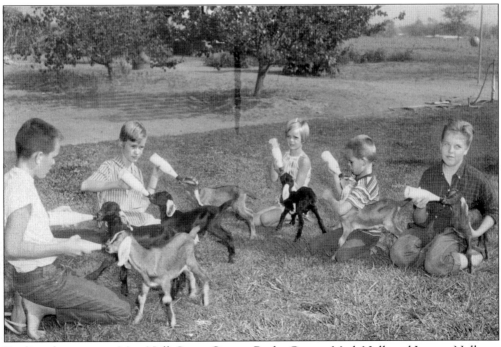

Feeding the goats are Matt Noll, Susan Gumer, Becky Gumer, Mark Noll, and Lauren Noll.

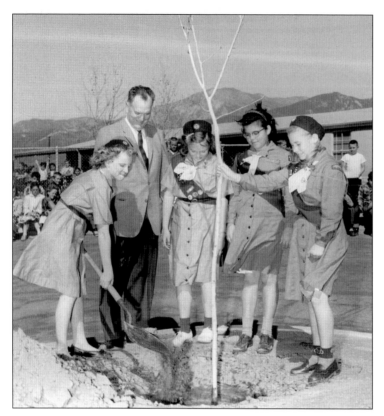

Children from the third, fourth, fifth, and sixth grades watch Girl Scouts from Troop 116 plant a fruitless mulberry during Arbor Week. From left to right are fifth grader Linda McCarty, principal Les Becker, fifth grader Verna Miller, fifth grader Joy Brown, and sixth grader Darline Moll.

The new 61-acre Yucaipa High School is under construction in 1965. During the five building phases, tours were given to the Yucaipa Valley PTA Council and other organizations in town. The first classes at the new school were 550 junior high students. After the first day, off-duty sheriff's deputies were hired to handle traffic and escort students through the crosswalk.

Thorton Kivett assists the new Miss Yucaipa Judy Larson in holding her scepter on February 10, 1966. The jeweled scepter was handmade by members of the Yucaipa Valley Gem and Mineral Society. The handle was inlaid wood with sterling silver work, adorned with gems of different colors and an amethyst in the middle.

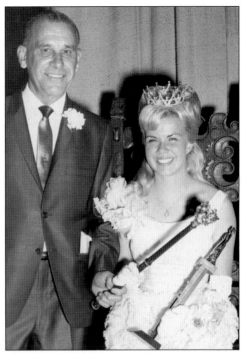

Local women, from left to right, Jo Koble, Betty Jordan, Kay Skyberg, Colleen Blakeley, Jackie Hermanson, Betty Martines, and Sally Lusby decorate the Yucaipa Christmas tree.

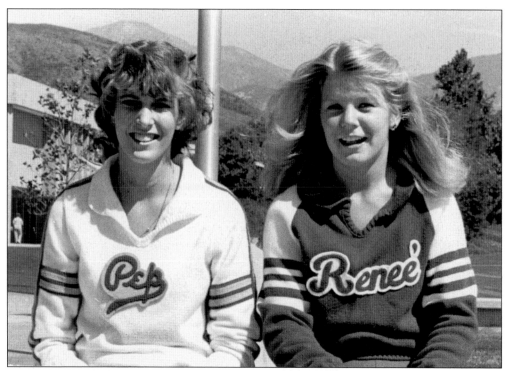

Yucaipa High School had moved to its new location on Yucaipa Boulevard by 1965. Here Pep Commission member T. Biddle and school mascot Renee Poplawski enjoy their new campus.

Brothers, from left to right, Al, Art, Jim, and John Braswell have been crooners since they were children. The four have lived and thrived in the community and shared their barbershop quartet talents at their businesses and at town events, including the Miss Yucaipa pageant.

Cows are loaded into trucks from the Mountain View tract. Pictured are, from left to right, Hank Finlay, Bud Palmer, unidentified man, and Madison Finlay (in the white T-shirt). Even with the new homes, agriculture continued to be part of local life.

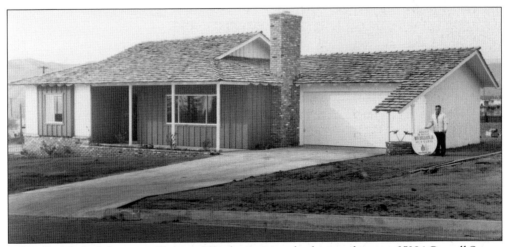

Bill Bullock Jr. built houses in Yucaipa. Here he is pictured at his own home at 35384 Cornell Street. Bullock also built the Knollwood and Lakeview Mobile Home Parks. Growth in the community brought local residents to request a land-use study and a master zoning plan.

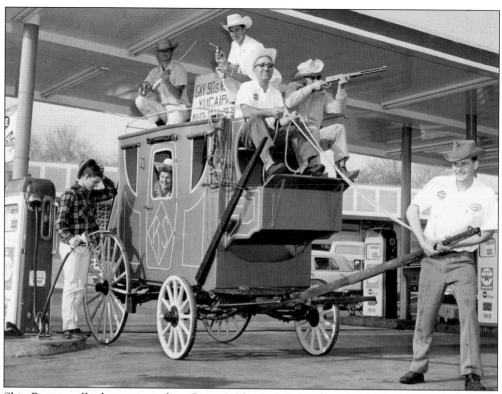

Skip Byrem pulls the stagecoach as Byrem's Flying A Service gets into the spirit of the fun of the Gay 90s Revue.

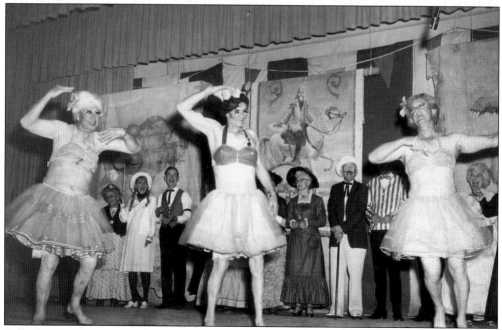

Belly dancers, from left to right, Ray Steward, Henry La Rosa, and John Kriwanek do their thing for "Gay 90's Goes to the Fair" show in 1966.

The Yucaipa Fire Station crew sits down to dinner. They are, from left to right, Mark Hirons, Dwayne Gaddy, Warren Keehnal, unidentified cook, Larry Young, and Lou Brundige.

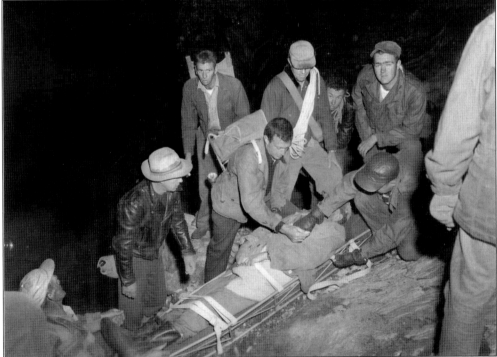

The San Gorgonio Search and Rescue team members find Paul Ford of Oak Glen, who had gotten lost in the mountains above Oak Glen. In the center are Deputy Willard Farquhar and Bob Dalgity. The search and rescue team was established at the Yucaipa Sheriff Station in 1958.

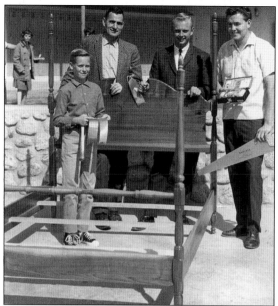

Yucaipa High School wood shop student Steve Firestone poses with his sweepstakes-winning bed frame. From left to right are Carlene Cremer (in the distance), prizewinner Steve Firestone with teachers Paul McCoy, Dan Klingbiel, and Jim Lee holding Firestone's prize—a set of tools.

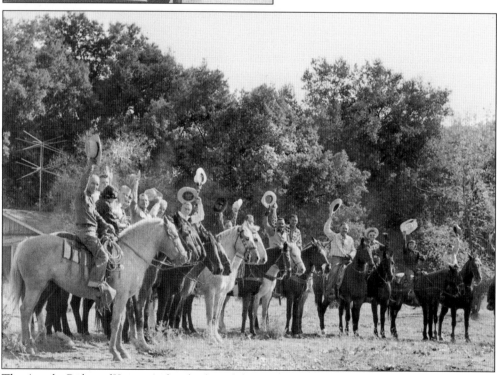

The Apache Riders of Yucaipa, a local riding club, wave their hats as they enjoy the great outdoors. By the middle of the 1960s, Leonard Covert, operator of the Yucaipa Farmers Cooperative and a community leader, expressed concern about the shrinkage of the area's farm acreage over the previous twenty years. The valley had changed from being a predominantly agricultural area in 1945 to a bustling residential area. Mobile home parks and homes were replacing peach and plum orchards. In fact, Covert noted, since the end of World War II, fruit orchard acreage in the Yucaipa Valley had diminished from 3,750 acres to 200 by the 1960s.

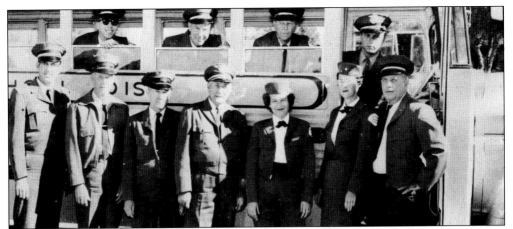

One of the biggest issues in the community in the 1960s was the need for bus service—both for schools and public transit. Roscoe Deaton started his bus business, and it continues today. From left to right, (first row) pictured in 1965 are school bus drivers Martin, Tharp, Robert, Zander, Nace, Mann, and Roscoe Deaton; (second row) Roscoe's sons, Deaton, Adams, Lawrence, and Bullock.

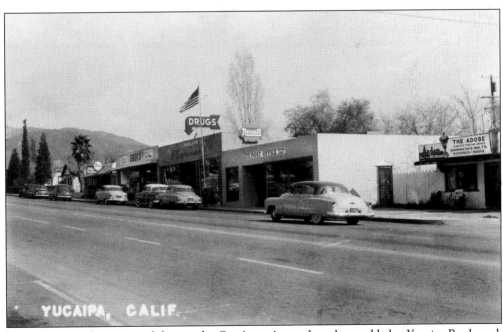

By the 1960s, a pharmacy and the popular Geer's men's store have been added to Yucaipa Boulevard. The telephone booth is still there and someone is using it. The Adobe café has fancied up and is a popular meeting place.

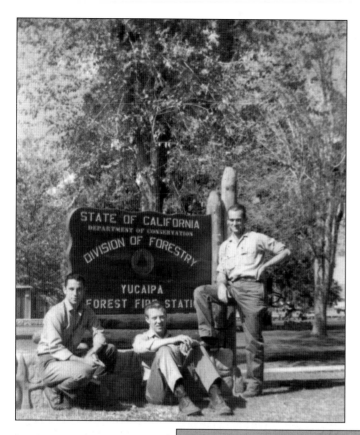

From left to right, firefighters Bob Martines, Mike Hannifan, and Warren Keehnal pose in front of the Yucaipa Fire Station sign in 1965.

Mike Petta of Mike's Barber Shop stands by his famous message board at his California Street shop. Mike and Jim, his son, have long been fixtures in Yucaipa society. In this photograph, Mike is announcing his candidacy to become the first mayor of Yucaipa. Incorporation drives were launched in the 1950s, in 1963–1964, and again in 1967. In the 1963–1964 effort, leader Dewey Herkelrath and the Citizens Committee on Community Development failed to get enough signatures. The 1967 effort was crushed in the voting booth, with 4,403 votes against, and only 1,235 for cityhood. A mayor was not elected until 1989.

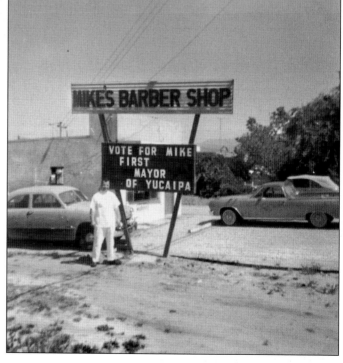

Jeannie Haralson and Harold Kolb show their spirit in 1967. Kolb was the president of the Yucaipa Board of Realtors at the time. Yucaipa works to retain its village charm and welcome new neighbors.

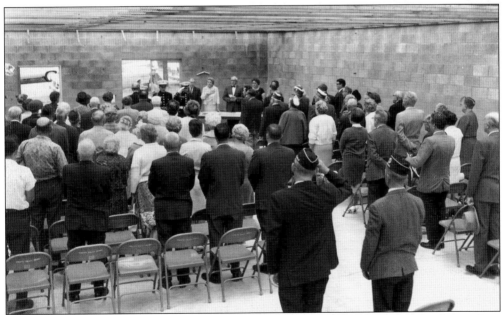

On October 6, 1966, Yucaipa Valley Welfare—established in 1949 and operated for 17 years from the basement of the Yucaipa Woman's Clubhouse—holds a special ceremony at the construction site of its new facility at 35075 Avenue A. Epsilon Sigma Alpha, the American Legion, Odd Fellows, Republican and Democratic Clubs, Gem and Mineral, the Jaycees, Grange, Woman's Club, and the Yucaipa *News Mirror* were among the donors who helped get the building made. At the event, 35 mementos from local organizations were placed in a cache box and preserved within the cornerstone of the building. Yucaipa Valley Welfare's Yucaipa Family Assistance program is still in operation today.

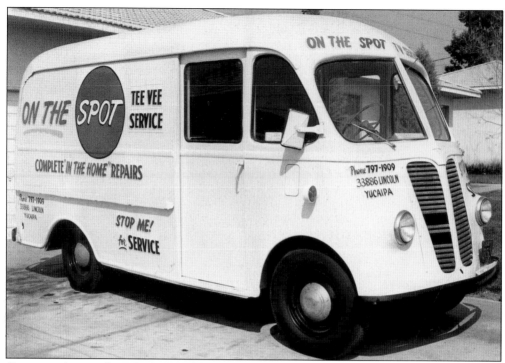

Operating from its Lincoln Street address, the On the Spot television service made house calls.

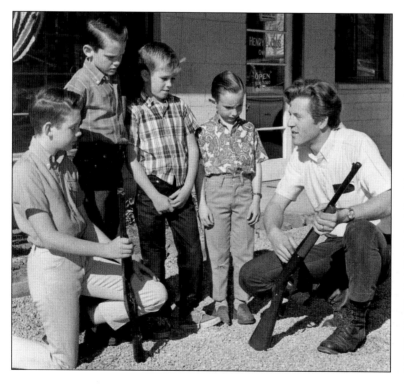

A January 1968 Yucaipa Valley Jaycees project focused on gun safety. Allen Jones, right, taught safety and marksmanship training with the assistance of the Yucaipa Valley Gun Club. From left to right are Jim Richardson, John Richardson, Randy Cobb, and Jeff Richardson. The Jaycee and Gun Club members in charge of the project included Noel Godfrey and Hank Cobb.

Donna Thorton (right), with an unidentified man, shows off the 4-H beef on the hoof in 1969.

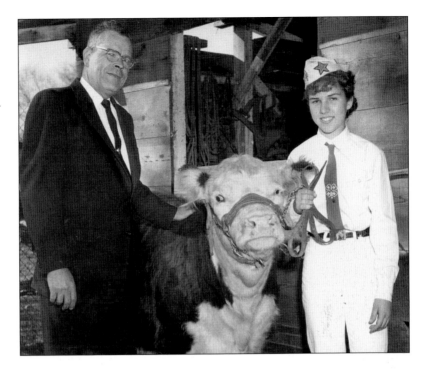

FFA president Mike Downer raised the Victorville County Fair champion Suffolk ram. Downer went on to become the Yucaipa postmaster for several years.

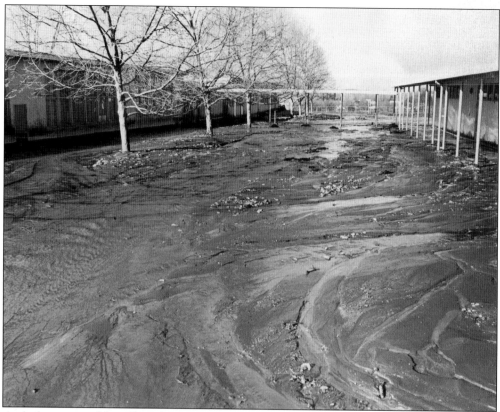

At the beginning of the valley's devastating February 1969 flood, Dunlap Elementary School operated as a disaster center. After the 100-hour deluge sent debris-laden mud and water knocking down fences and devastating the campus, refugees were moved up to the Yucaipa Intermediate School.

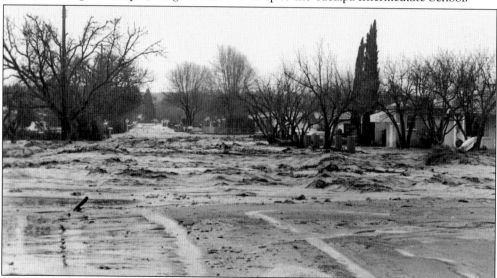

The torrents, shown here at Twelfth Street and Avenue E, grew worse as the day wore on. Some homes were inundated with several feet of mud. The California Highway Patrol closed the freeway, and all accesses between Yucaipa and Calimesa were cut off.

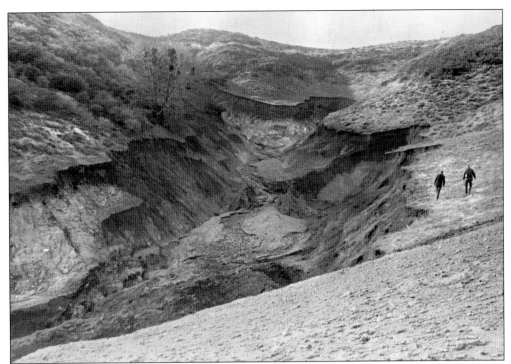

Tons of mud moved from Davies Canyon on the south side of Pisgah Peak after the land reached a saturation point. The mud moved into Wildwood Canyon during the flood and some of it ended in Loma Linda, along with chicken coops and anything else in its way. The waves of mud were well over 10 feet high. In this photograph, Bob Bise is the man on the right inspecting the damage.

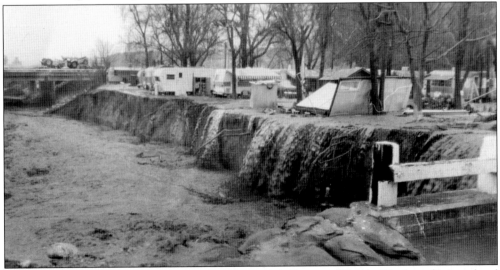

In this photograph, Cooper's Trailer Court at Fourteenth Street and Dunlap Boulevard is inundated by floodwater before it reached Wilson Creek. The banks collapsed, leaving one trailer perched precariously on the edge of the channel. Midway Trailer Park on Avenue G, however, was spared as the flood torrent re-entered Wildwood Creek just below Sixth Place. Ultimately, the storm ended and the cleanup began. No lives were lost, but it would be 25 years before the flood control improvements would be paid off.

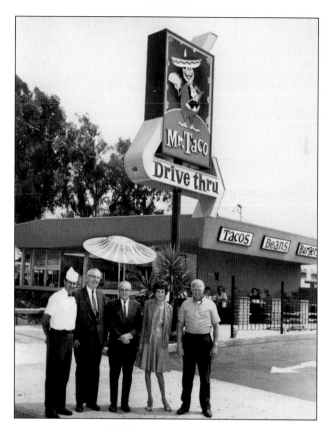

From left to right, Don Minnis, Ralph Lewis, Ray Arrowood, Mildred Jackson, and contractor John McKune are at the opening of the Mr. Taco on Yucaipa Boulevard in 1968. It is now Mr. Crum's Donut Shop.

The building at the corner of Yucaipa Boulevard at First Street has housed many different businesses over the years, including a feed store and a paint store.

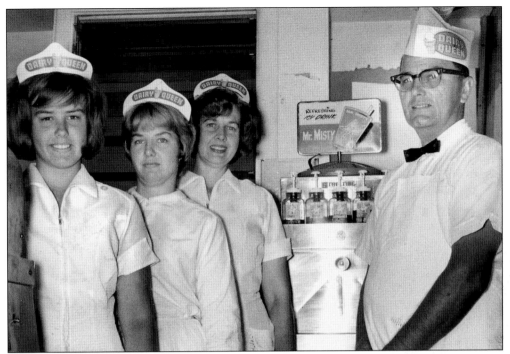

Bob and Ruby Root owned this Dairy Queen at 35158 Yucaipa Boulevard and it was always popular, but so was the Dairy Queen at 33940 County Line Road, which they opened in 1968. The Roots eventually modernized the Yucaipa facility into the Sizzle Kitchen. In this photograph, the Root family presents Mr. Misty icy drinks.

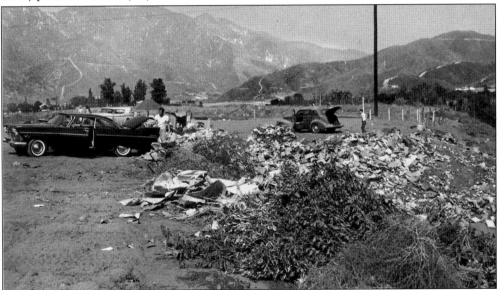

In the early years, garbage disposal was often handled by landowners merely dumping waste over the side of their property lines. As the local population grew, communal dump sites like this one on Fremont Street were established. Another major dump sat nearby on the northeast corner of Bryant Street and Oak Glen Road, where the flood control detention basins are still located. A third site on Oak Glen Road ceased operations in the 1980s.

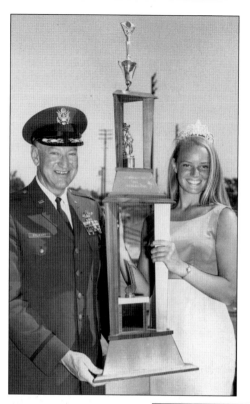

Miss Yucaipa of 1969, Susan Anton put the town on the map when she became Miss California in 1969 and second runner-up to Miss America in 1970. In this 1968 photograph, the latter-day *Baywatch* actress presents the Yucaipa Valley Days sweepstakes trophy to Col. William Stewart. Yucaipa Valley Days included whiskerino contests and hometown fun.

In 1969, Ambers "Sonny" O'Neil Shewmaker of Yucaipa was killed by a gunman while performing his duties as a California Highway Patrol officer. Shewmaker grew up in town and left his wife, Kandie, and two young sons, Troy and Tyler. More than 350 law enforcement officers attended the funeral. Gene Myreck of Sacramento was found guilty of the murder and died in prison.

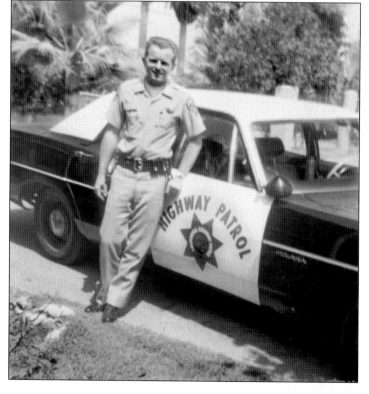

These honorary life members of the Yucaipa PTA are, from left to right, Claire Elder of Dunlap Elementary, Dorothy Morbitzer of Yucaipa High, June Richardson of Yucaipa Elementary, Eva Pitter of Yucaipa Intermediate School, Pat Franklin of Calimesa Elementary, and LaVone Ames of Valley Elementary.

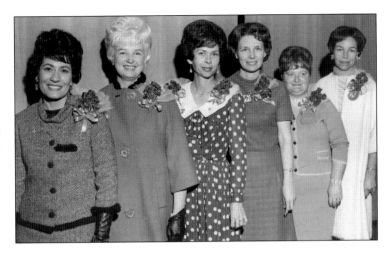

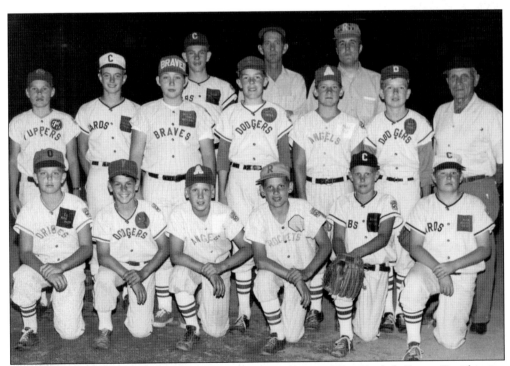

The Yucaipa Little League Major League All-Stars were (first row) Ron Fosdick, Danny Davidsmeier, Lance Hallberg, Mark Britton, Tom DeJager and Jeff Barr; (second row) Rob Kimbler, Harold Ellis, John Prusvic, Chris Nettles, Steve Wassell, coach LeRoy Nettles, Jerry Woodrow, coach Dennis Harper, Mike Adamaski, and Joseph Parrella. In 1981, as shortstop for the University of Southern California Trojans, Davidsmeier won the team's MVP award. In 2009, he was named to the Yucaipa Athletic Hall of Fame.

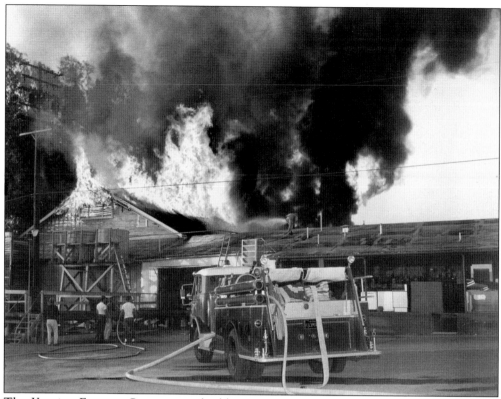

The Yucaipa Farmers Cooperative building went up in flames despite the effort of the fire department.

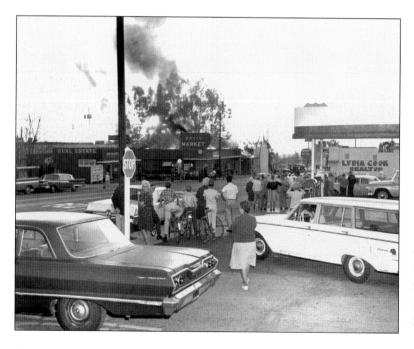

The community watches the flames from the corner of First Street and Yucaipa Boulevard.

Four

THE 1970s

LIFE, LIBERTY, AND LOVING IT

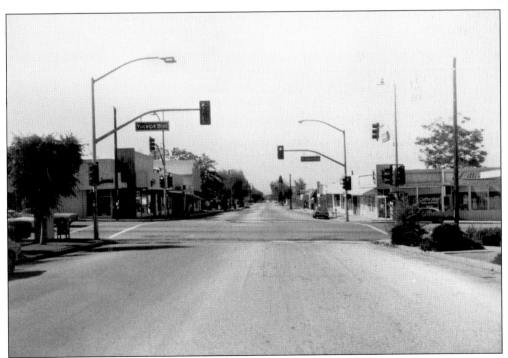

This look south at the intersection of California Street and Yucaipa Boulevard shows the uptown business district in the 1970s—now boasting crosswalks, streetlights, and modern signals.

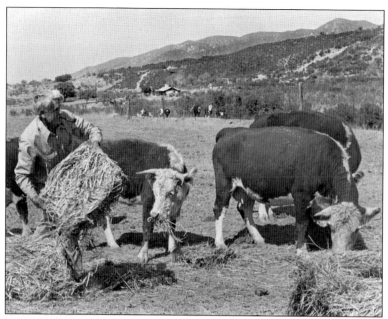

Jim Tucker feeds cattle on his North Bench Ranch in 1970. Jim and Irene Tucker moved to the property in 1969 and held a cattle drive to move their herd there. After retiring in 1976, Tucker continued working his herd and raising hay. Irene sold her Academy Real Estate business in 1989 and the couple moved to New Mexico.

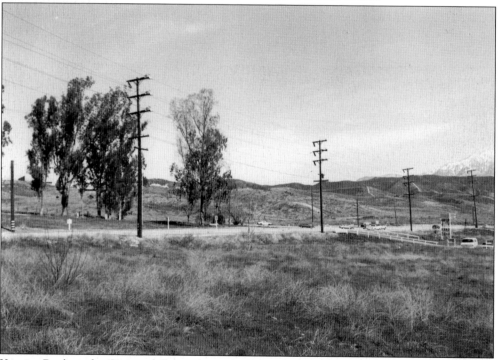

Yucaipa Boulevard at Sixteenth Street shows the Yucaipa Valley Chamber of Commerce welcome sign (lower right, with club insignias on display) and open hillsides. Later in the 1970s, the agricultural preserve, which limited development, was lifted from 769 acres of land at the request of Stan Chapman, an owner of Yucaipa Valley Acres. The action began to pave the way for development. Land planning became a bigger issue. The development however, came to a halt when a building moratorium was imposed by the Water Quality Control Board. The required sewer plant was a controversial topic.

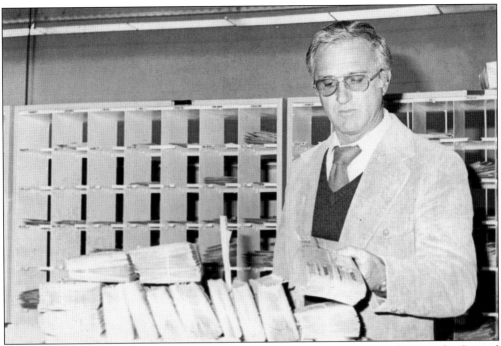

Postmaster Jim Mann demonstrates how to count mail volume. He is working in the Second Street post office, a 6,084-square-foot facility built in the 1960s.

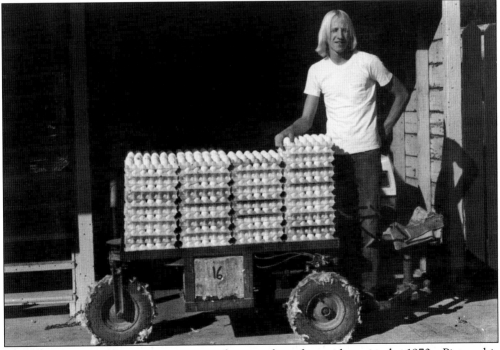

Local chicken ranches were a major employment base for residents in the 1970s. Pictured is an unidentified Yucaipa High School student as he collects eggs. Note the feathers on the cart's wheels.

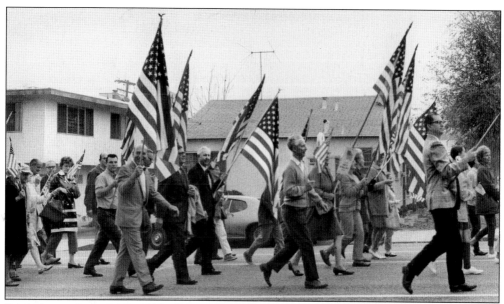

Patriotism and parades would be Yucaipa's middle name if it had one.

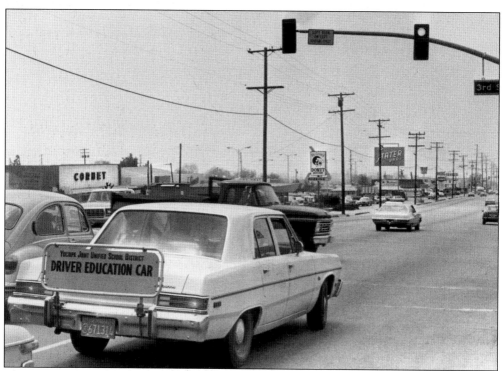

The Yucaipa Joint Unified School District offered driver education classes for local students. Here a lesson is underway on Yucaipa Boulevard at Third Street. Note the power lines, the Cornet Store, Stater Brothers, and Mr. Crum's—formerly Mr. Taco.

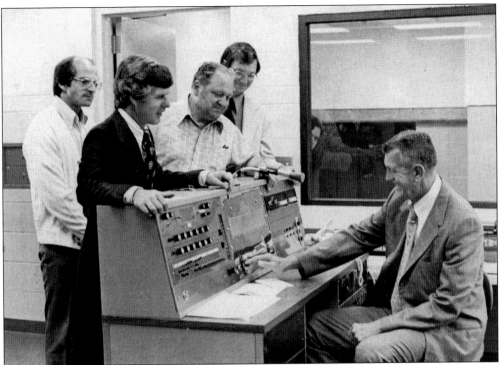

An unidentified technician from San Bernardino County (far left) watches as, from left to right, county supervisor Dennis Hansberger, community leader Geno Gasponi, Judge Jim Edwards, and Yucaipa Sheriff's Station Captain Dewey Ringstadt appreciate the station's new system.

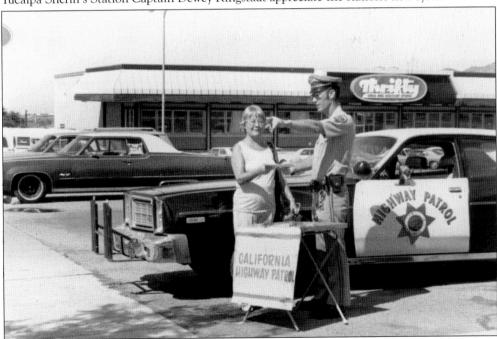

Before incorporation, the California Highway Patrol handled traffic issues in Yucaipa. In this 1970s photograph, officer Ken Morris assists Gladys Johnson.

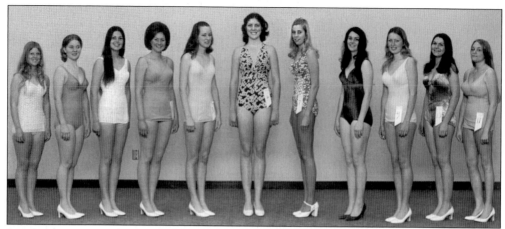

Local young women line up for the 1973 Miss Yucaipa Pageant. From left to right are Deena Wheeler, Bonnie White, Cindy Carrera, Gail Utterback, Linda Donnan, Cherri Linnastruth, Cynthia Thompson, Grace Eaton, Melissa Graves, Nancy Walker, and Sherri Carman.

Seniors line up to get free flu shots at Santa Fe Federal Savings and Loan on upper Yucaipa Boulevard.

Ronald Reagan spoke in Yucaipa. Pictured are Lorene Arrowood Slovensky, Wallace McKnight, Nancy Reagan, Barbara McKnight, and David Hansberger at a campaign event.

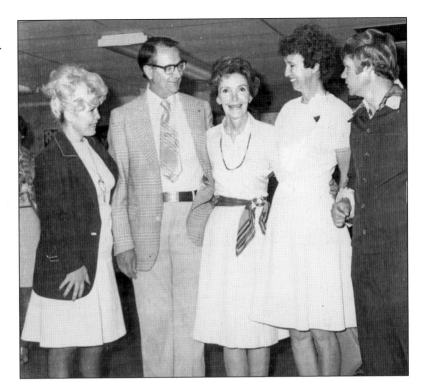

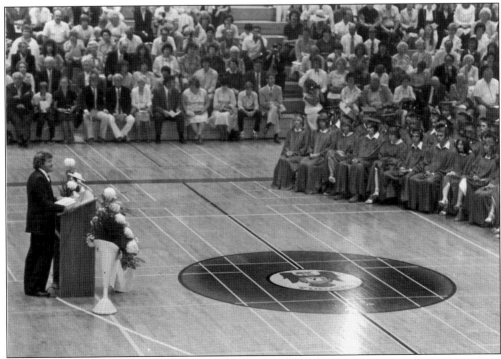

Yucaipa High School students celebrate graduation at the new campus.

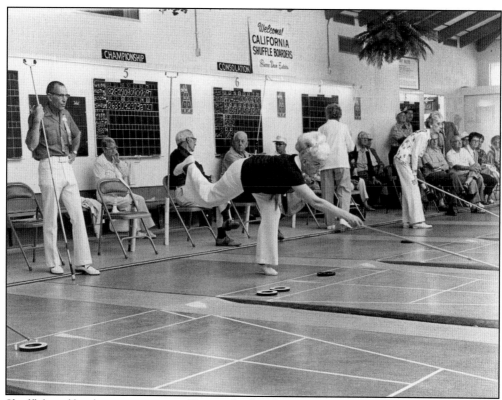

Shuffleboard has been a major sport Yucaipa for decades. In this photograph, Marge Bond shuffles. She and her husband won the championship on April 26, 1974.

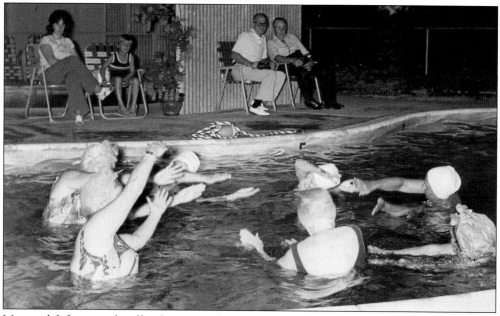

Most mobile home parks offered communal pools, and as this August 10, 1977, photograph attests, water exercise was popular with the parks' residents during the hot summer months.

In 1976, Col. Joseph Parilla (right) presents Henry "Hank" Cobb (center) with the Col. Joseph Parilla award—the most prestigious of all Yucaipa Little League honors. Harlan Aldrich (left), a former recipient, looks on.

The Yucaipa Park District (YPD) expanded its holdings in the 1970s to meet the needs of the area's growing population. Here the merry-go-round at Seventh Street Park is full of children at play. In 1976, the 75-acre Wildwood Canyon Park was created with funds provided by the 1975 Bond Act. While the oak-treed area had been used as a park for most of the century, the land had been owned by the ASD Corporation until 1973.

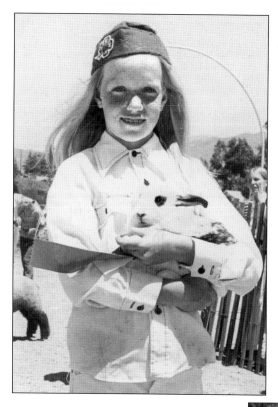

Susie Forsberg holds her first-place-winning rabbit, Bo. At Yucaipa High School, the agriculture program continued to thrive and expanded into a mini-farm. YHS agriculture instructor and FFA advisor Carl Arend worked with students to construct a shade house, which is a shaded area for garden plants to be grown.

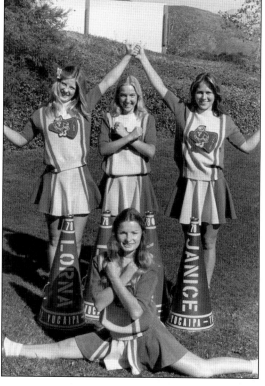

Yucaipa High School varsity cheerleaders show their school spirit in 1978. Mary Mishodek (front) does the splits, while, from left to right, Lea Whittington, Lorna McKune, and Janice Leach pose behind her.

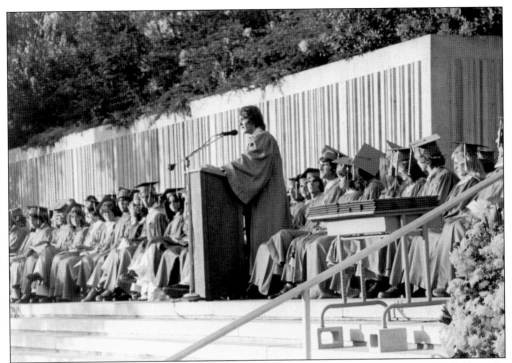

For years, Yucaipa High School graduations were held in the quad of Crafton Hills College. In this June 21, 1978, photograph, Chris Roberts speaks to the crowd.

In January of 1972, the Finkelstein Foundation donated 251 acres of additional land to Crafton Hills College. Their original donation was for 167 acres in 1966 with 76 acres more in 1970. The first buildings on the campus were nearly completed in 1972. The land gift included property near Fourteenth Street designated for recreation and the Yucaipa High School. The Yucaipa Soroptimist Club donated the original bells for the clock tower.

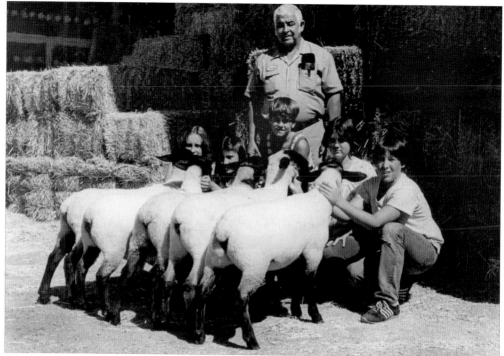

Frank Draeger of Draeger's Feed, which was located on Calimesa Boulevard north of County Line Road, was much appreciated for his involvement with agriculture students, especially the Future Farmers of America and the 4-H. Here he works with students who are raising sheep.

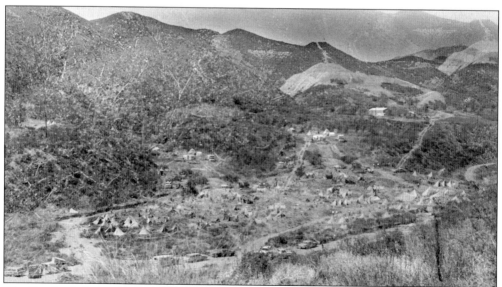

The Grayback Council of Boy Scouts held this Camp-o-ree along Wilson Creek in the 1970s.

In 1979, the community had full-time paramedic service. From left to right are Chris Wurzell, Mike Marlow, Ken Pitts, and Cleve Bangle.

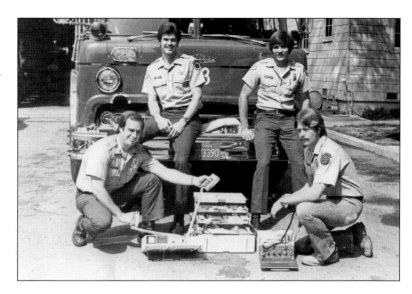

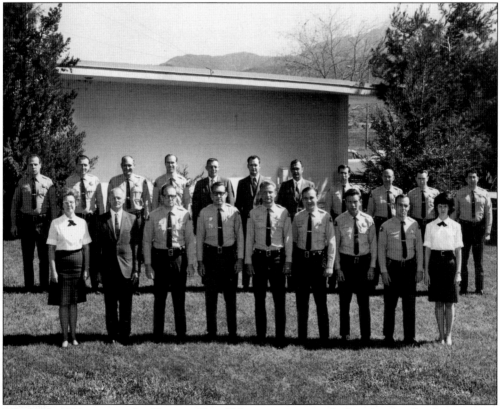

The 1970–1972 crew at the Yucaipa Sheriff Station is pictured. Standing in the first row are, from left to right, Jean Sedgewick, Al Hull, Monty Lindquist, Larry Wilson, Jim Cansler, Kenny Goperton, Bill Loenhorst, Ron Durling, and Marlys Bushnell. In the second row are Jim Tomes, Bob Widlund, Gene Irgang, Ray Dorsey, Wally Anton, Kenny Blackwell, Willard Farquhar, Bruce Rouse, Phillips, Jon Stroop, and Ernic Reynosa.

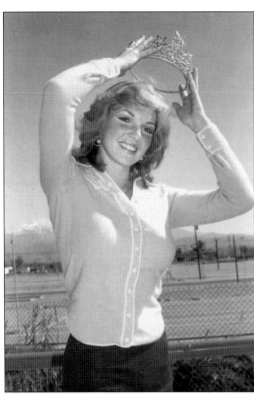

Becky Raff, the daughter of Dale and Rose Raff, was the 1975 Miss Yucaipa.

The Avenue A station crew included, from left to right, Warren Keehnal, Mark Hiron, and Steve Hansler.

The 1979 Yucaipa Intermediate School Faculty Follies included Lois Swaynie (second from the top) and Gail Ingram (front, blowing bubble gum).

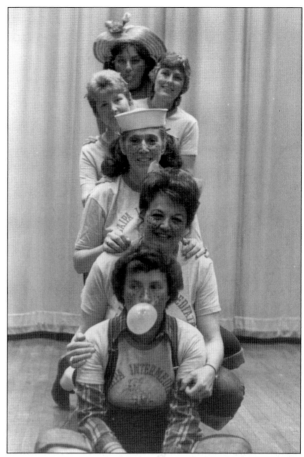

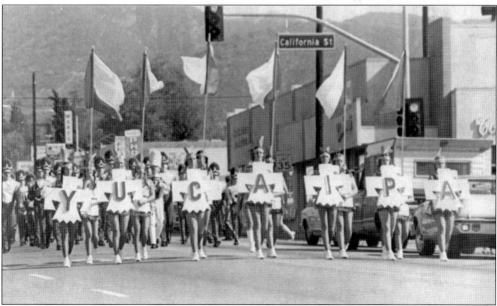

The Yucaipa High School Thunderbirds lead the Christmas parade.

Hugh Arther, right, was a popular man with a big heart. He was on the U.S. Olympic Team on two occasions as a horseshoer. He retired from the U.S. Army Calvary after serving for 21 years. He became a furrier in town and a leading member of the Yucaipa Valley Lions Club who worked the snack shack at youth events and park concerts.

Margaret Keller, Judge Bill Clark, and supervisor Dennis Hansberger hold the plans to the Yucaipa Equestrian Center at Avenue G and California Street. The center was a community project, and Keller and Clark were leaders of the committee. The center officially opened in October 1973, when the Yucaipa Valley Lions Club held a grand opening and inaugural show.

Conley's Pharmacy at the northeast corner of Yucaipa Boulevard and California Street was long a community hangout with its popular lunch counter. From left to right are J. W. "Bill" Conley, Wendy Conley Minton, Helen Watson, Mickie Flaherty, and Jack Halcrow.

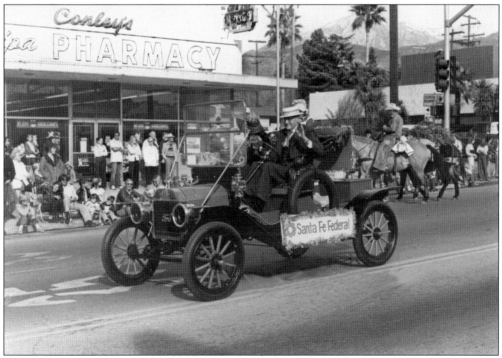

The sign in the background reads Calimesa 3 miles and Beaumont 10 miles as the Christmas parade winds down the decade in front of Conley's Pharmacy.

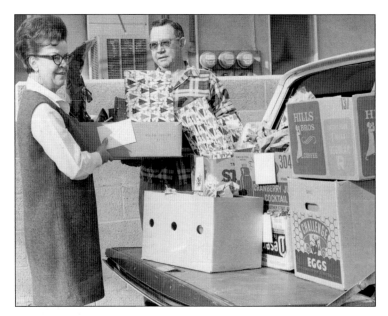

Vi Price and Howard Simcox of Yucaipa Valley Welfare put together Christmas gifts for local less-advantaged families.

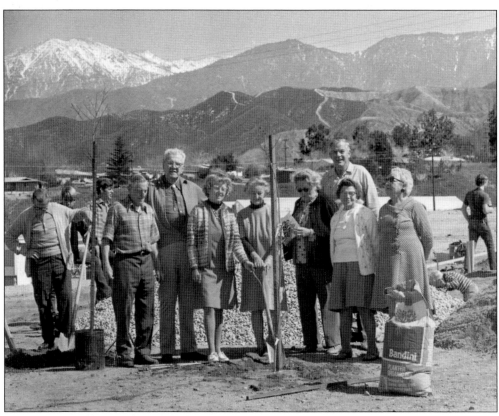

The Yucaipa Valley Garden Club plants trees at the new Equestrian Center. The Garden Club held popular flower shows over the decades that drew huge crowds and hundreds of entries.

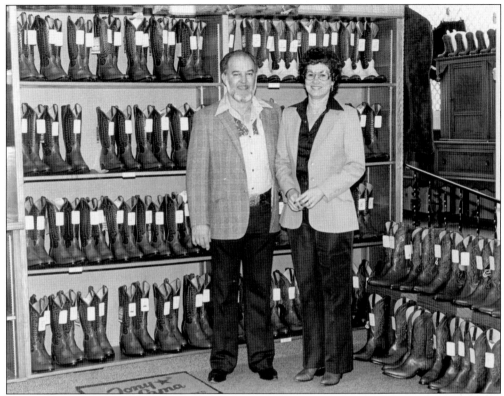

Dot and Don Farnworth ran Circle Eight Western Wear, a popular shop, located at the former pharmacy building on California Street. Circle Eight offered a complete line of Western wear, leather repair, square dancing costumes, and leather goods.

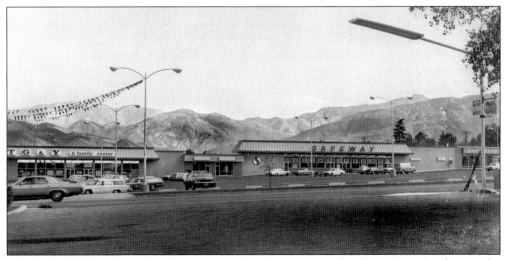

Yucaipa was growing as the 1970s progressed, with T.G.&Y. and Safeway stores anchoring the Fourth Street shopping center. Uptown at Adams Street, the Yucaipa Valley County Water District offices were getting very cramped. District manager Ira Pace was working on a building fund.

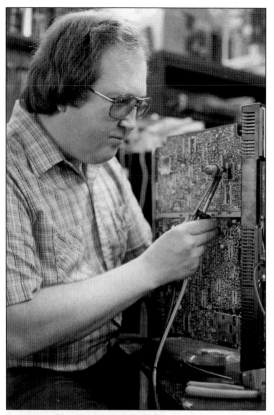

Mike Gross works at the family business—Gross TV—on California Street. His parents, John and Polly, opened shop in 1946 with sales of televisions, radios, record players, records, sheet music, and some instruments. Their store specialized in music along with the television and repair. Polly was a musical wizard. Today, her son, Mike, continues to share his time and sound system equipment for the judges and announcers' stage for every Lions Club Christmas Parade, as well as for community meetings.

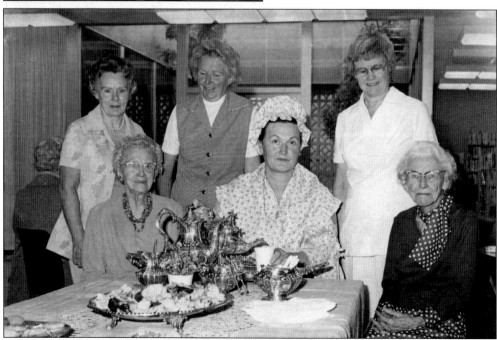

The Yucaipa Woman's Club holds a Library Tea. The club, which started in 1910, has continued its philanthropy over the decades.

The Petta family is pictured in 1970. From left to right are Mike, son Jim, and daughter Elizabeth. Jim now operates the Mike and Jim's Barber Shop and Elizabeth owns the Red Rock Barber Shop in Sedona, Arizona.

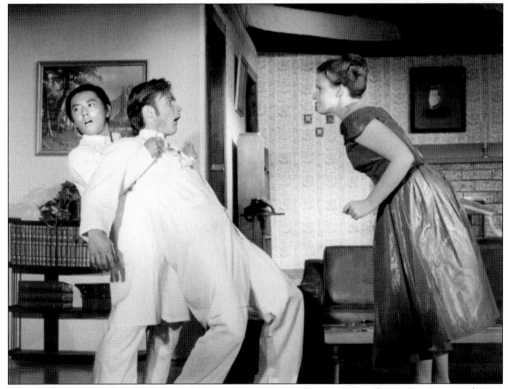

Yucaipa High School as the Drama Club presents *Harvey*. From left to right are Japanese exchange student Shunji Suzaki, Mark Cannon, and Lesa Whittington. The students built the sets, hung the lighting, and provided their own costumes. Cannon has since become an internationally known magician and escape artist.

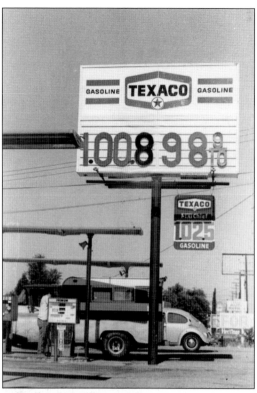

The reality of gas prices going over $1 hit local motorists in their wallets in June 1979. In the 1970s, Yucaipa's population went over 20,000 for the first time.

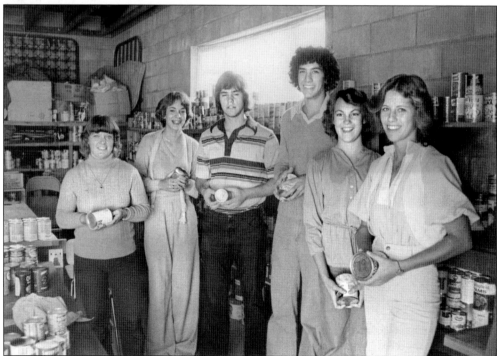

Students from the Yucaipa High School class of 1979 hold a can drive to benefit Yucaipa Valley Welfare's Family Assistance program.

Five

THE 1980s

YUCAIPA STANDS ON ITS OWN

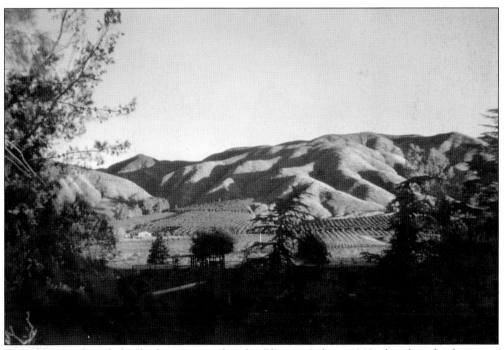

The photograph, titled "Shadows," was taken by Chester Cole in 1982, shot from his home on Washington Drive, looking north at the Crafton Hills. The property was owned by the Chapman family, who developed the 1,000 acres into today's Chapman Heights. The day the citrus trees in this photograph were destroyed was very traumatic for the community.

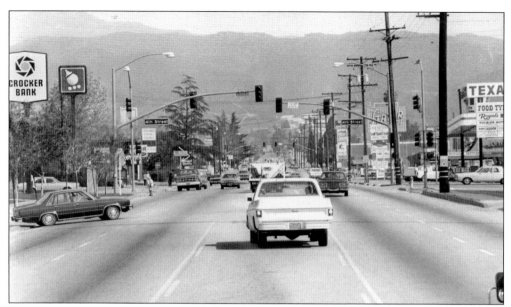

New businesses went into operation in the 1980s, some of them replacing older establishments. Homes that were on the boulevard in many cases were moved or taken down to provide more commercial frontage on Yucaipa Boulevard. When the County of San Bernardino Planning Department encouraged commercial developments off the boulevard and along major streets, local landowners declined to sell, saying they preferred to keep the business area along the main thoroughfare.

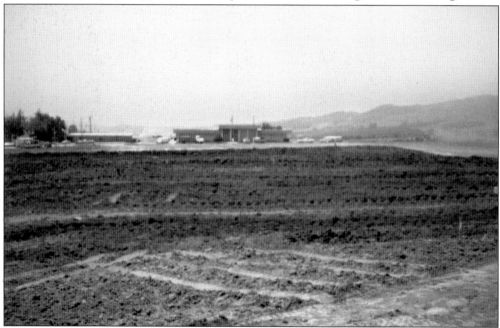

The Yucaipa Branch Library and Yucaipa Sheriff Station can be seen along Fifth Street in this 1980 photograph. The land is being broken for the shopping center anchored by the first Vons supermarket. Around this time, the town went into an uproar when an adult bookstore opened for business down the boulevard, in violation of the Yucaipa Community Plan. After picketing and petitions, the store was closed with the assistance of county supervisor David McKenna.

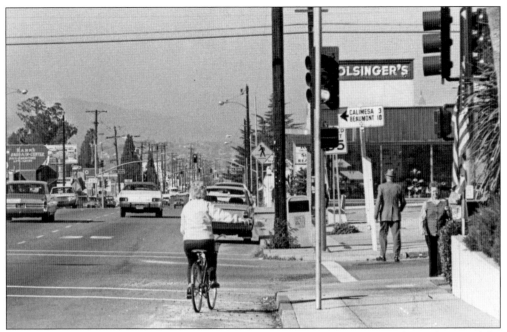

A bicyclist motions her intent on Yucaipa Boulevard at California Street in the early part of the decade. Yucaipa's Dial-A-Ride service started in 1982. The power poles seen in this photograph were taken down and utilities laid underground in the mid-1980s.

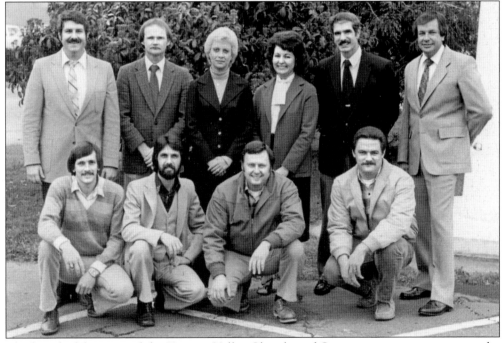

The board of directors of the Yucaipa Valley Chamber of Commerce was very active in the community through the 1980s. Chamber members in this photograph are, from left to right, (first row) Randy Miller, Gordon Leslie, Jim Klocek, and Jim Frisch; (second row) Jan Black, Jerry Wright, Wendy Conley Minton, Ann Atkinson, Joe Calpino, and Gaylon Jarvis.

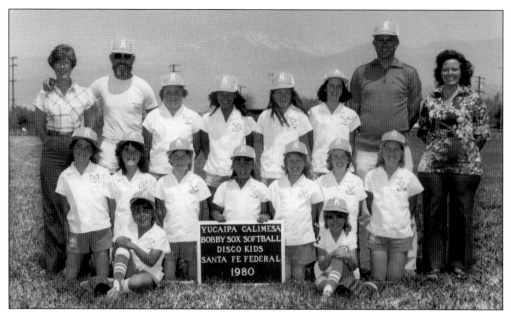

Local sports continued to thrive in the 1980s for both youth and adults. This Yucaipa–Calimesa Bobby Sox Softball team included (first row) Sue Allocca and Shelley Ellis; (second row) Babi Clay, Kristie Hendrix, Cathy Henderson, Lynn Allocca, Theresa Mancini, Kimber "K. J." Jones, and Kim Yeager: and (third row) manager Linda Hendrix, coach Larry Clay, Tylene Endo, Roxy Wong, Carol Hurt, Dawn-Marie Mallie, coach Charlie Hurt, and chaperone Cheryl Mallie.

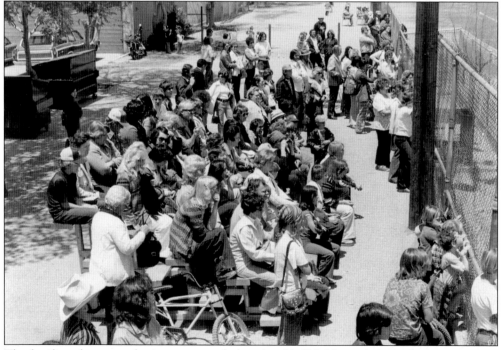

The families of sports enthusiasts met regularly at local ball fields, in this case for a soccer game at the field on California Street. Yucaipa Valley Youth Soccer Organization, which started in the 1970s, was an instant success and its teams soon filled every available spot to practice or play.

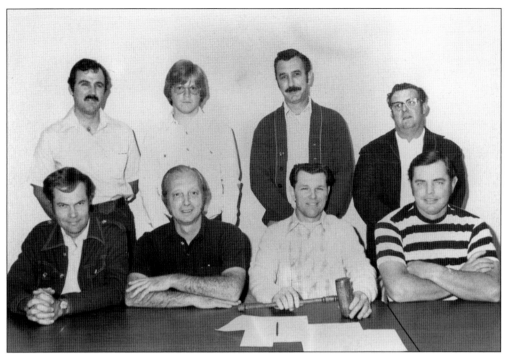

Yucaipa Valley Little League also continued to be successful throughout the decade. This 1980 picture shows the YVLL board of directors, including Howard Reeves (front row, second from the right). Another board came into being in March of 1981 when nine members were named from a field of 65 applicants to the Yucaipa Municipal Advisory Council. Charles Brammer, Dan Crain, Marie Gray, James Klocek, Rebecca Robar, Claire Sample, Garey Teeters, Frank Wohlgemuth, and Larry Young were sworn in to address local issues and recommend actions to the county supervisor's office, which it did until incorporation.

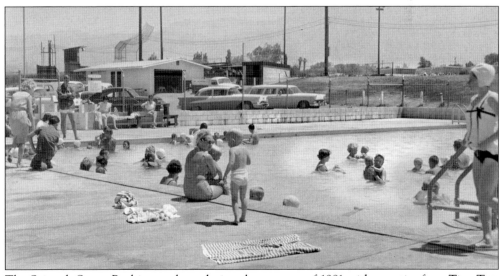

The Seventh Street Pool is very busy during the summer of 1981 with aquatics from Tiny Tots Swim programs to open swim times and Yucaipa Swim Team activities.

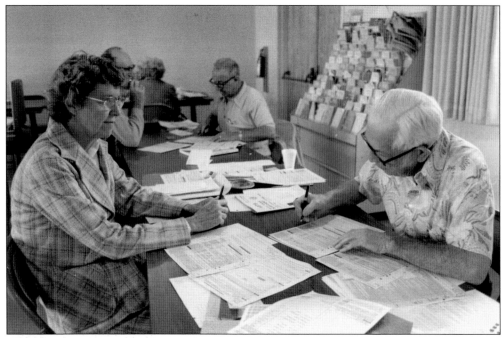

The American Associates of Retired Persons' Wayne Beers assists a senior in filing her taxes in 1980 at the town's community center, renamed the Scherer Center after Paul and Helen Scherer and later in the decade.

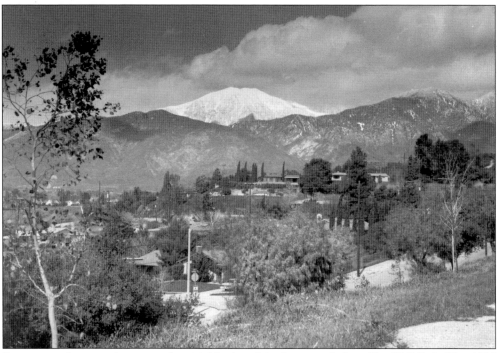

Snow-capped mountains crown the neighborhood, looking north from Flag Hill Park. The 1980 census counted 23,345 people living in Yucaipa. In the background, San Bernardino rises behind Yucaipa Ridge.

The Yucaipa Regional Park opened on July 4, 1981, with a huge community celebration. In the morning, at the dedication ceremony, a huge U.S. Air Force plane flew very low over the crowd. Gordon Leslie and Claire Marie Gray coordinated the event, which included games, a Native American community dance, parachute show, and a fireworks display off the dam.

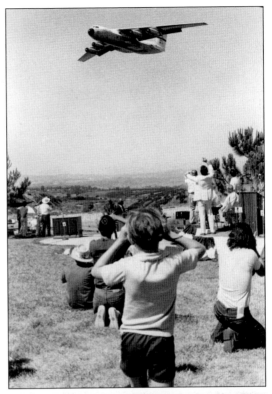

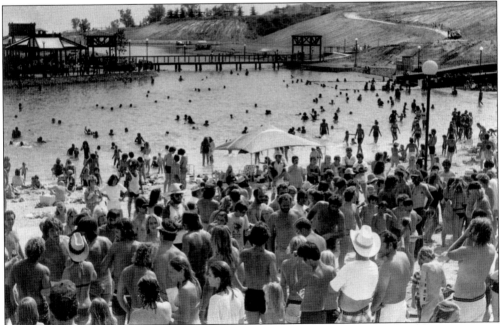

The new regional park's swim lagoon was soon crowded with bathers. The concept for the park started in the 1960s. In 1968, the San Bernardino Valley Municipal Water District designed the project as one big lake, but a geological study showed faults and the park finally came to fruition with the three little lakes.

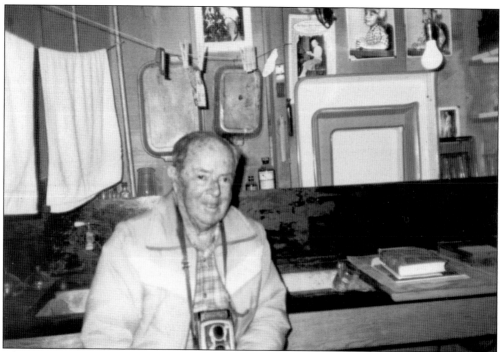

Chester Cole captured much of Yucaipa's history with his cameras. Here he is pictured in 1980 in his basement workshop, where he processed the photographs that remain historically important today.

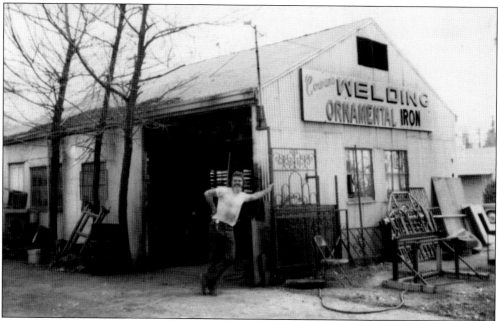

In 1981, Joe Cowan poses outside Cowan's Welding. The building that houses Cowan's at Avenue A and California Street has been around since the first decades of 1900s. It was known as Jim's DeJersey's Machine Shop around 1945 and later became Yucaipa Welding and Machine Shop. Jim and Betty Martines owned the shop in the 1950s. In 2009, it was still under Cowan's ownership.

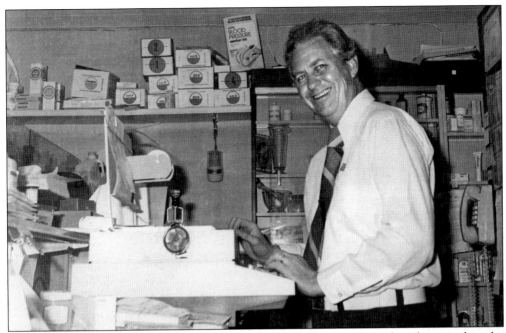

Jim Richardson not only operated Richardson's Pharmacy for many years, but also served on the board of trustees of the Yucaipa School District. He attended art classes at Crafton Hills College and is an accomplished sculptor.

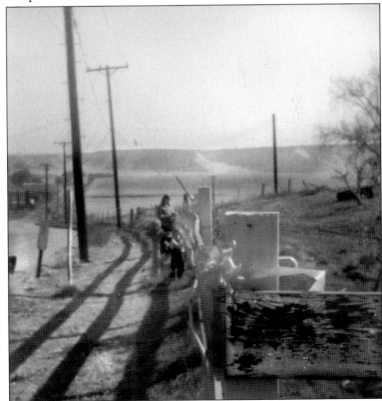

On Pres. Ronald Reagan's inauguration day in January 1981, yellow ribbons were hung on trees and fences nationwide to welcome back the returning hostages from Iran. In the view looking east from Sixteenth Street and Outer Highway 10, Kelly Patrick Lamaster puts ribbons on a fence with the help of her daughter, Shannon Lamaster.

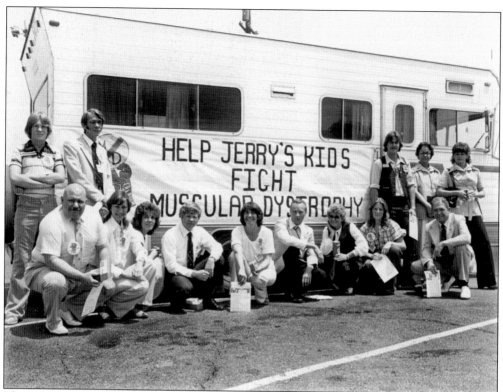

The community has always supported humanitarian causes. In this picture, a handful of Yucaipans are taking a stand against muscular dystrophy. Pictured from left to right are Jay Teeters, Hugh Colburn (squatting), Darrel Teeters, Heidi Whitlock, unidentified woman, Dave Hansberger, Robert C., Sarah Cotten, Bob Stalter, Dottie Bertsch, William Bertsch, Dorothy Bertsch, and Betty West.

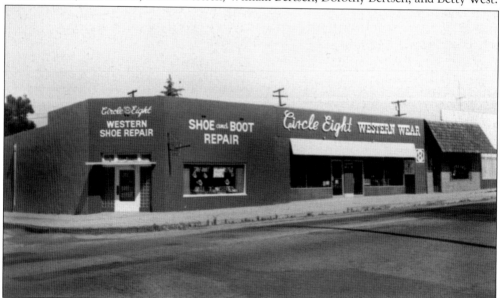

By the1980s, Rockwell's Pharmacy and Yucaipa Theatre had become the popular Circle Eight Western Wear store. The buildings still stand today.

Lorraine Patterson poses with a handful of auction bucks at Food Fair, which was celebrating its anniversary.

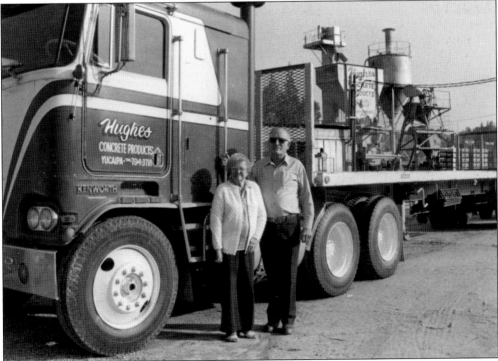

In the 1980s, Hughes Concrete had to move from its location at the corner of Yucaipa Boulevard and the freeway to make room for the new bridge and interchange. Mr. and Mrs. Hughes stand by one of their tucks.

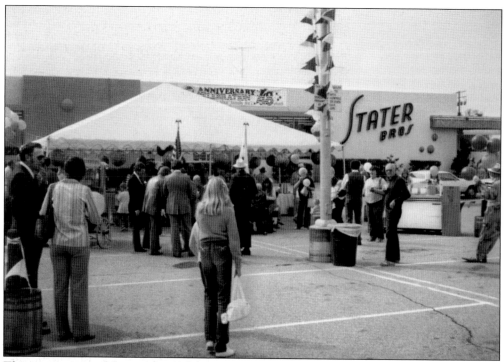

The community celebrates the 48th anniversary of Stater Brothers at its shopping center on Yucaipa Boulevard near Fourth Street.

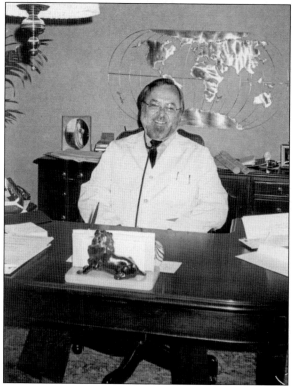

Gerald Rutten, M.D., operated the Yucaipa Family Medical Group in facilities on Fourth Street. The center included a clinical laboratory, radiology department, and offices for dental and specialty practices. The center was later sold to Redlands Community Hospital. Rutten was renowned for his poker games and involvement in community service projects.

Yucaipa Adult School principal Dr. Tom Cahraman is pictured with, from left to right, Pat Reed and Eve Pitter at the opening of the Third Street facility. Cahraman was active in the Yucaipa Joint Unified School District from 1965 to 1983, holding a variety of positions.

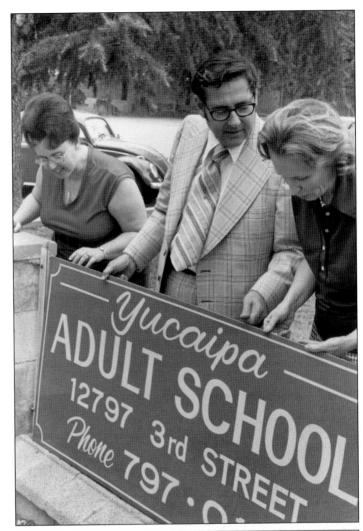

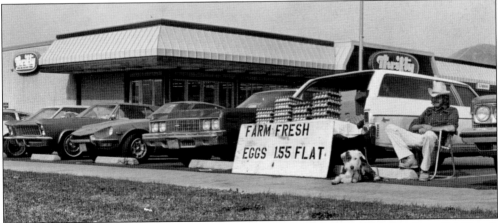

Greg Isaac and his dog Hope hawk eggs along Yucaipa Boulevard in 1982. The Isaac Egg Ranch on Oak Glen Road provided eggs to many of the community's restaurants for many years.

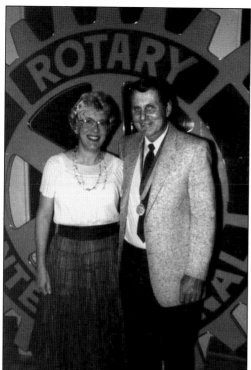

Ann and Dick Whitlock pose at a Yucaipa Rotary Club event. The Whitlocks operated Patrick's Septic Tank Service in town. Whitlock was also Rotary Club president. In 1985, Ann published *Yucaipa: Valley of Reflections*, a pictorial book containing the history of Yucaipa.

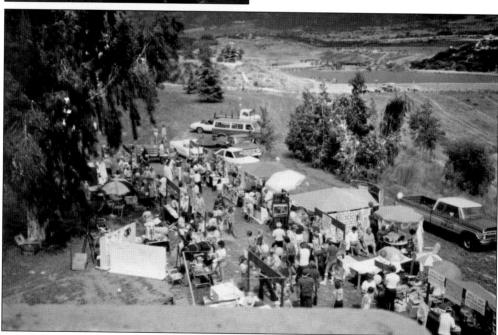

The community has always enjoyed gatherings. From the first Apple Shows of 1911 to the early 1940s to the peach festivals and Yucaipa Valley fairs to the Yucaipa Valley Days gatherings, which were held over the years in different locations. In the 1970s, Yucaipa Valley Days had a five-day run. In this 1980s photograph, the chili cook-off is in action at the fair in the new Yucaipa Regional Park on Oak Glen Road.

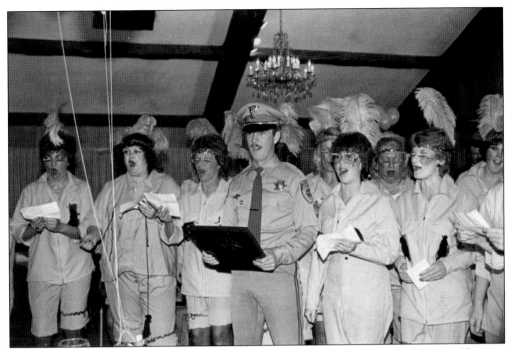

California Highway patrolman Phil Alford leads the Rock-outs, also known as the Chirping Chippies, in singing to their beloved retiring fire chief, Larry Young at the Calimesa Country Club.

Lou Young and her husband, retiring fire chief Larry Young, roar with laughter as Young is roasted with glory at the 1983 celebration. San Bernardino County supervisor Barbara Riordan can be seen in the center of the photograph. At the time, she was a field representative for supervisor David McKenna. She was appointed to replace him as supervisor shortly after the event.

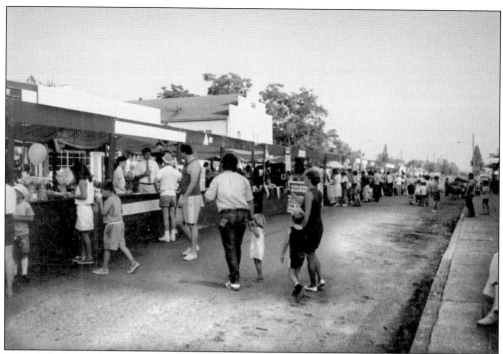

The Yucaipa Merchant's Fair was held on California Street. The booths had originally been built by Jan Black for the Yucaipa Valley Fair.

Sheriff's Captain Dewey Ringstadt also got the "Yucaipa Valley Sallys" out in prison garb for his retirement celebration April 29, 1983. From left to right are unidentified, Janene Klocek, Kathy Montgomery, Char Whittington, Dewey Ringstadt, Wendy Conley Minton, Donna Post, Randie Goehring, Claire Marie Teeters, and Garey Teeters, who served as master of ceremonies.

The Great Quake Players are shown presenting its first melodrama *Up the Yucaipa Valley, or Her Father Was Not to Blame* on September 23, 1983, in the Fine Arts Building at Yucaipa High School. The play was part of that year's Yucaipa Valley Days as well. The proceeds went to local disaster preparedness. In this photograph, the gunfighters from the play take a tumble.

The Great Quake Players's second play, a year later, was called *When the Buzzards Return to Yucaipa, I Will Return, or Who Shot Diamond Dave?* Ultimately, the group produced over $14,000 to assist the local disaster preparedness efforts led by the Yucaipa Valley Emergency Services Committee.

Two boys show their support of the Yucaipa Amphitheatre project, a bicentennial effort to build a community bowl for special events. Sites considered were in the new Yucaipa Regional Park and near the Yucaipa High School. After years of fund-raising, promotions, and site planning, the funds were donated to help create the amphitheatre at the Yucaipa Community Park.

The Patrick family celebrates William and Grace Patrick's 60th wedding anniversary on October 3, 1982, at Yucaipa Regional Park. Pictured are, from left to right, Grace and William Patrick, Annie Gardner, Jim Neal, and Bob Patrick.

Al Newell, founder of Newell's Nurseries, purchased a nursery from Harold Bliss in 1975. His daughter, Melody, and her husband, Bill Funk, now own Newell's and continue the tradition of providing fine service to the people of Yucaipa. Al continues to work at the nursery. Here he checks out a pot at Newell's on Yucaipa Boulevard.

Rocky Cobb (left) and Phil Ervin work at Cobb's Printing Enterprise on California Street. The family and the business have been renowned for its community support and philanthropy. Cobb was named Yucaipa Citizen of the Year in 2007.

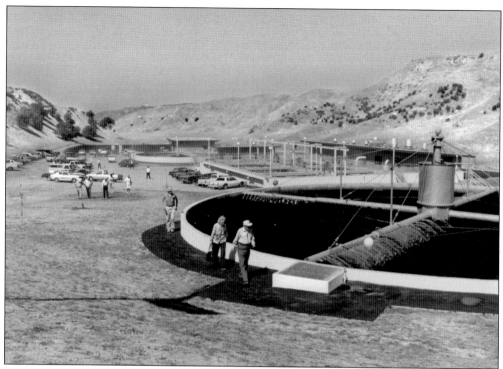

After 15 years of struggles over sewer site locations, lawsuits, environmental impact reports, and the acquisition issues of the 80-acre location in Crow Canyon, a sewer plant was dedicated on September 1, 1986, with a reception and tours for the community. The massive hook-up of residents and mobile home parks began.

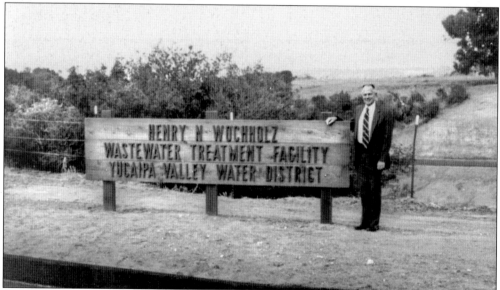

Life as the community knew it changed the day the Yucaipa Valley Water District opened its new sewer plant allowing for development and removal of the construction moratorium. The facility was named after Hank Wochholz (pictured), a popular longtime district board member and leader in the community.

An incorporation drive was started in 1986, led by Max Trayer of the Yucaipa Cityhood Committee. That effort, known on the November 1987 ballot as Measure L, failed by a vote of 4,941 to 4,051. Another drive headed by the Yucaipa Political Action Committee led by Julian Parrino started in late 1988. In this photograph, some of the 19 candidates for city council are pictured at the June 1989 Merchant Fair on California Street.

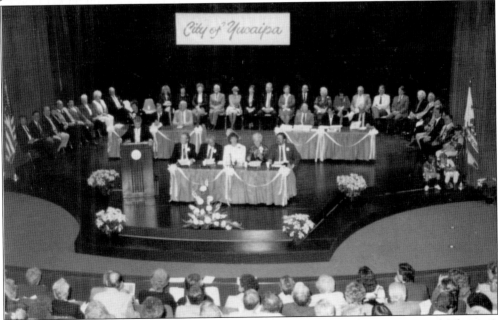

On the November 3, 1989, Measure K—calling for Yucaipa cityhood—was approved. The city's official date of incorporation is November 27— the day the San Bernardino Country Board of Supervisors passed the resolution that included ratifying the election. The new city held its swearing-in ceremonies at Crafton Hills College on December 1, 1989. A few months later, the 1990 census would report 32,824 residents in the new city. Over the next two decades, Yucaipa would be one of the most fiscally stable cities in the county.

www.arcadiapublishing.com

Discover books about the town where you grew up, the cities where your friends and families live, the town where your parents met, or even that retirement spot you've been dreaming about. Our Web site provides history lovers with exclusive deals, advanced notification about new titles, e-mail alerts of author events, and much more.

Find Your Place in History.